IMAGES OF ENGLAND

SOWERBY BRIDGE

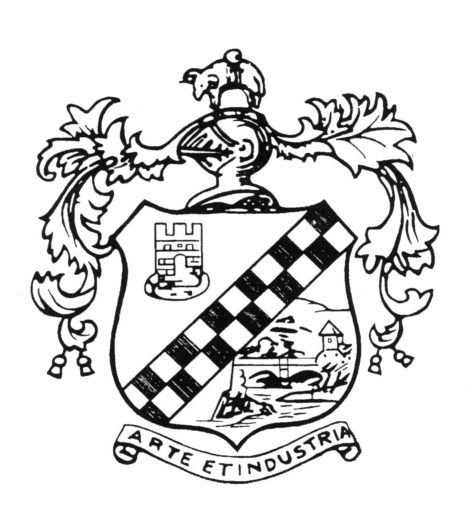
ARTE ET INDUSTRIA

IMAGES OF ENGLAND

SOWERBY BRIDGE

DAVID CLIFF

The
History
Press

Frontispiece: Sowerby Bridge coat of arms. This was never an official coat of arms and was created by two local historians at the beginning of the twentieth century. The shield is divided by a diagonal strip in the blue and gold chequered pattern taken from the coat of arms of the Earl's Warren, who owned the Sowerby Bridge area during medieval times. The tower is a representation of the castle said to have stood at Castle Hill, Sowerby. The bridge is the Sowerby Bridge. The motto *Arte e Industria* means 'Art and Industry'. The coat of arms can still be seen on the window above the main entrance door to the former council offices in Hollins Mill Lane, and also on the war memorial at the entrance to Crow Wood Park.

First published in 2006 by Tempus Publishing

Reprinted in 2009 by
The History Press
The Mill, Brimscombe Port,
Stroud, Gloucestershire, GL5 2QG
www.thehistorypress.co.uk

British Library Cataloguing in Publication Data.
A catalogue record for this book is available from the British Library.

ISBN 978 07524 3772 9

Typesetting and origination by
Tempus Publishing Limited.
Printed in Great Britain.

Contents

Acknowledgements

I have to thank Heather Karpicki and the ladies at Sowerby Bridge Library for their valued assistance on my many visits where I delved into the amazing local history collection they have there – a collection of which much more use could and should be made. Although the collection is large, Heather would be very pleased to receive any items concerning the history of Sowerby Bridge and District. Original items (photographs, postcards, documents and so on) are preferred but copies are also most welcome. They will be well taken care of. The majority of the photographs in this book are taken from the library collection and reproduced with the permission of Calderdale MBC Libraries, Museums and Arts. Most of the other photographs and documents are from my own collection.

I would like to thank Mr A.G. Ingham for permission to reproduce the photograph of the Drill Hall. My thanks also to Mr John Furbisher, editor of the *Halifax Courier,* for his permission to use the photographs which originate from there.

Every effort has been made to contact the copyright owners of all of the photographs; however, some of the photographs have been in the library collection for many years and it has not been possible to determine copyright status for them all. Should copyright holders come forward after the publication of this book then a full acknowledgement will be included in future editions.

My thanks also to Mr David Buxton of Tempus Publishing for his encouragement in getting this project off the ground.

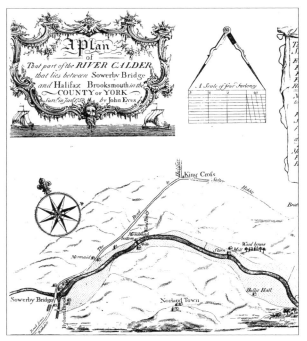

A plan of the part of the river Calder that lies between Sowerby Bridge and Halifax Brooksmouth in the County of York, surveyed in January 1758 by John Eyes. The Old Brig Chapel is shown next to the bridge amongst a few other buildings and buildings are shown up Sowerby Street, then known as Pighill Street. The Mermaid Inn was later renamed The Wharf and stood on the site of the present Wharf Garage.

Introduction

The recorded history of Sowerby Bridge can be traced back to the Domesday book of 1086 where 'Sorebi' is recorded as one of the nine berewicks of the manor of Wakefield. It was formerly the property of the Crown but was granted to William, Earl Warren, after the Norman invasion. The forest of Sowerbyshire became a favourite hunting ground for the Norman overlords and tradition has it that a castle stood on Castle Hill at Sowerby. No archaeology has been found to prove this, but if such a structure did exist it was probably only a wooden hunting lodge of some description. Manorial courts were held at Sowerby until 1274 when they were transferred to Wakefield.

The old spelling of 'Sorebi' explains why we pronounce it that way today. The most popular meaning of the name is 'settlement on sour land', although another interpretation is 'safe settlement'. The first mention of a bridge at the junction of the rivers Calder and Ryburn is in 1314, and this was almost certainly a wooden bridge which was replaced by a stone one in the sixteenth century.

As the textile trade developed in Halifax and surrounding neighbourhoods, a hamlet grew up around the bridge. The excellent water supply from the two rivers soon led to the erection of fulling mills along their banks, the first recorded one being in 1296. When John Eyes drew up his map of 1758 there were fifteen waterwheels operating in the Sowerby Bridge area.

The cloth trade developed and before long certain 'clothiers' were buying yarn and supplying it to the hand-loom weavers working at home. The 'pieces' of cloth were then bought from the weavers by the clothier who sold them at places like the Halifax Piece Hall. By the eighteenth century the clothiers began to realise that it would be more efficient to put up a building and employ people to work there, spinning and weaving, for a wage. The manufacturing system was born and people were forced to move down from the hillsides to the valley bottoms in order to find work in the mills. These mills were water powered in the early days and required iron-founders and engineers to build and service their machinery. This resulted in these two trades developing in tandem with textiles, with steam engines being developed later to replace water power.

Increasing trade demanded better communications and the 1735 turnpike road, passing through Sowerby Bridge, improved travel between Halifax and Rochdale; other turnpikes soon followed. The bulk carrying of goods became a reality with the opening of the Calder and Hebble canal in 1770 and the Rochdale canal in 1804. The coming of the railway in 1840 was a further catalyst for economic development in the town.

By 1851, Sowerby Bridge was a town with a recorded population of 4,633. There was, however, one barrier to further progress: the town had grown up on the boundaries of four old townships. These were Sowerby, Norland, Warley and Skircoat and where you lived in the town determined to which township you paid your rates. This was resolved in 1856 when the town was granted its own local board of health – in effect a town council – and the town boundaries were drawn up taking land from the four townships. There was much rejoicing when this event was celebrated at its 50th anniversary in 1906 and to a lesser extent at its centenary in 1956.

A trade census was taken in 1861 which gave the following figures for the numbers of workers in the town: woollen, 1,918; worsted, 992; cotton, 721; iron, 727; dyeing, 297; chemical, 119; railway, 85; corn, 58; building trades, 270; and smaller trades, shops and so on, 532, making a total of 5,719. In the main the iron, dyeing and chemical industries were all associated with the textile trade.

The town was at its zenith around 1900 and the good years lasted well into the twentieth century. There were plenty of jobs to be had and textile workers were recruited from other

depressed areas of the country. My own grandparents came from Batley in the 1930s and my mother came down from Sunderland to work at Morris's mill at Triangle in the 1940s.

Electricity replaced steam, forcing the closure of the firms making steam engines such as Pollit and Wigzells. Market forces – that is, competition from the Far East – resulted in the rapid decline of the textile industry in the 1960s and '70s.

Another blow came in 1974 when part of the town's identity was lost with the merger of Sowerby Bridge Urban District Council with other local authorities to form 'Calderdale', thereby bringing to an end 118 years of the town having its own local council. The railway goods yard closed; the canals were disused and the fire station decommissioned. For a time, Sowerby Bridge seemed to be in terminal decline. It was an industrial town without much industry, 'the forgotten town of Calderdale'.

Happily, the decline has been reversed in the last few years and the town has taken on a new lease of life. Organisations such as the Sowerby Bridge Forum have led the way but many other organisations and individuals have made their own contributions. The canal has been re-opened with a tunnel under Wharf Street, leading into what is now the deepest canal lock in the country. The canal basin has been renovated, old mills have been converted into flats and apartments, a new supermarket has been built (with another in the pipeline), new street lighting has been installed, and a new industrial estate planned. Sowerby Bridge Civic Society, of which I have the honour of being treasurer, continues in the footsteps of the old council in keeping a watching brief on all these developments.

The world in which we live is constantly changing and we soon forget what things were like in times past. While writing this book, I have become acutely aware of the amount of change going on in the town. Buildings are disappearing and an unprecedented amount of building work is going on. Books such as this one help us to remember. I hope you enjoy this brief excursion into the past.

David Cliff
Sowerby, 2006

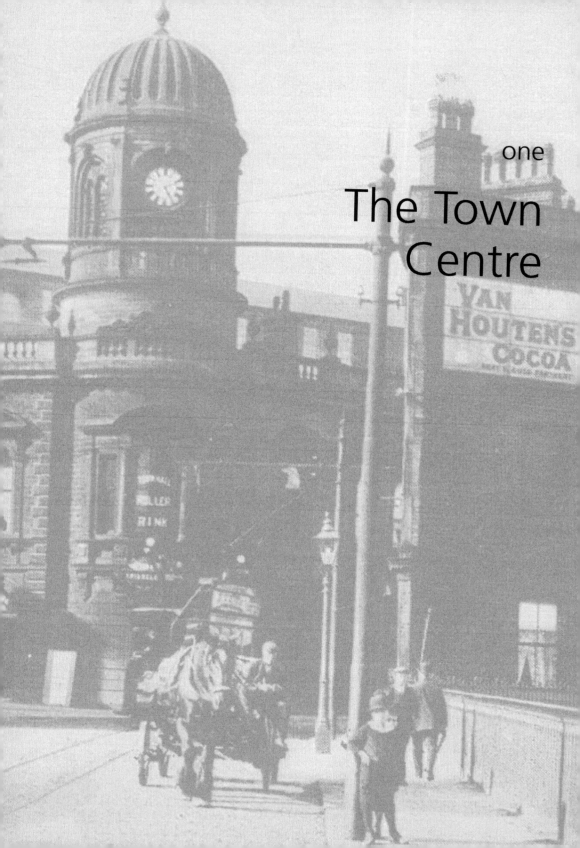

The Town Centre

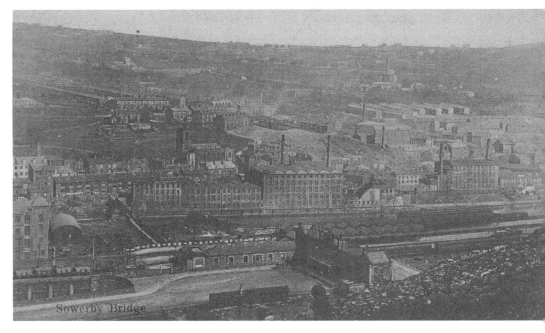

General view of the town from the Norland hillside, from a postcard dated 1906. The railway station is at the bottom centre and above the platforms can be seen the footbridge over the river Calder which links the station to the town centre.

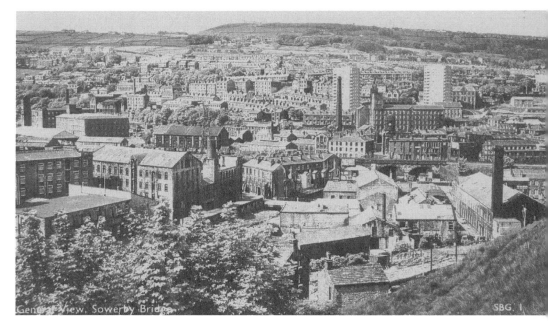

A general view of the town centre (*c.* 1970) showing the mills and factories clustered along the valley bottom and the rows of terraced houses for the workers, rising up the Warley hillside. The twin tower blocks of Ladstone and Houghton Towers seem strangely out of place here.

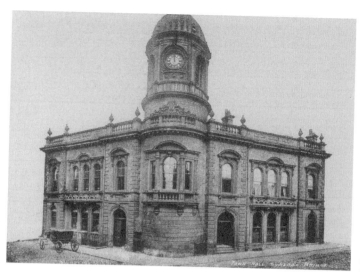

Sowerby Bridge 'town hall' was built by a private company in 1856-7 who hoped that the newly formed Sowerby Bridge council would purchase it from them. They never did so, which resulted in the building being nicknamed 'the town hall that never was'. Built in a prominent position near the end of County Bridge, the building was symmetrical until the Hollins Mill Lane wing was demolished. The clock tower was paid for by public subscription as a memorial to the ending of the Crimean War. The remaining portion of the building now serves as a branch of Lloyd's Bank, but it has had many uses over the years. It has been used for meetings, concerts, as the first police station in the town, and even as a cinema and roller skating rink.

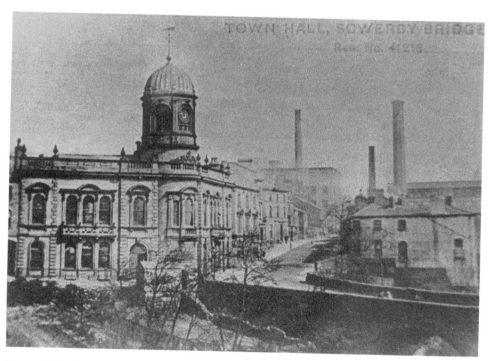

The newly built town hall, *c.* 1860. At this time there were gardens where central buildings now stand and rowing boats could be hired for trips on the river. Of greater interest is the view of the bridge before it was altered; the stone parapets later being removed and the bridge widened.

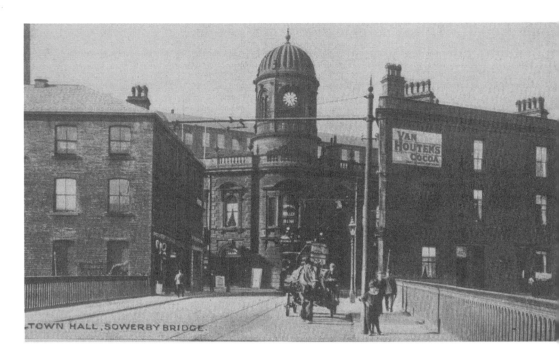

TOWN HALL, SOWERBY BRIDGE.

TOWN HALL, SOWERBY BRIDGE.

NEW YEAR'S CARNIVAL AND COMIC CONTESTS.

MONDAY AND TUESDAY, JAN. 1st & 2nd, 1900

THE GREATEST, GRANDEST AND BRIGHTEST
HOLIDAY ENTERTAINMENT

Ever given in this Town.

CONJURERS, JUGGLERS, BANJO and
MANDOLINISTS,

WHISTLING SOLOIST and

BIRD MIMICRY.

The Best and Finest COMIC SINGERS of the North
of England.

Every Artist a Star, and every Star of the First
Magnitude.

For full particulars of this Stupendous Holiday
Programme, see Window and Handbills
and Advertisements.

Such Prices never known before at Holiday time.

Front Seats 1s., Second Seats 6d., a few Back at 3d.

Above: View looking over County Bridge towards the town hall. The name 'Liberal Club' can be made out above the arched doorway of the town hall, as can 'Town Hall Roller Rink' on the window of the tower. The corner of the building on the right began sinking towards the river and had to be demolished. It stands on the site of the Old Brig chapel and is now a paved seating area.

Left: Advertisement from *The Sowerby Bridge Chronicle*, 29 December 1899. A whistling soloist and bird mimicry at the town hall shows they were easily amused in those days!

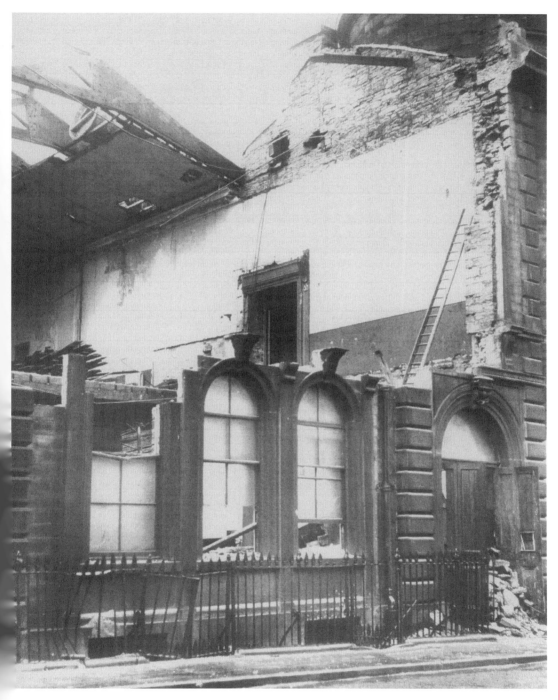

Demolition of the Hollins Mill Lane wing of the town hall, 19 November 1963. The large upper room could seat 700 people and the opening concert was held on 30 September 1857 when Haydn's oratorio, 'The Creation', was performed. The main singer was Mrs Susan Sunderland, 'The Yorkshire Queen of Song'. Reserved seats were five shillings and second seats two shillings and sixpence.

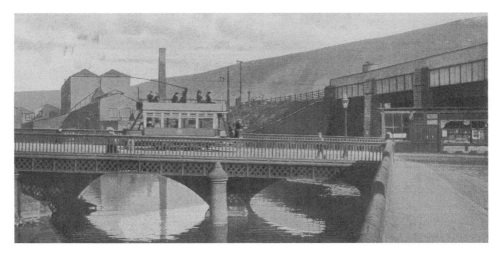

A postcard dated 1908 showing a tram crossing County Bridge on its way to Triangle. Open-top trams had to be used on this route to enable them to pass under the railway viaduct. The wooden buildings at the end of the bridge have long since gone. In later years one was a cobblers shop and the other a taxi office. The original stone arches can be seen under the bridge. Daniel Defoe crossed the bridge in 1725 and described it as 'a stately stone bridge of several stone arches'.

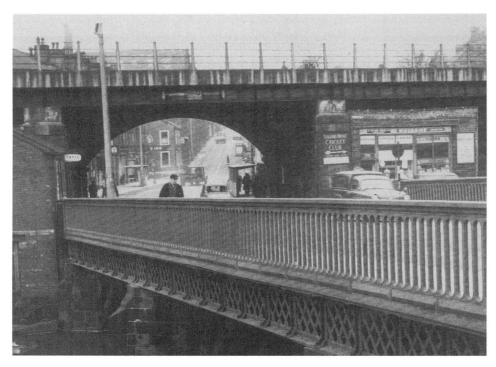

County Bridge, from which the town gets its name. The name 'County Bridge' dates back to 1673 when the West Riding took over responsibility for the maintenance of the bridge following the flood damage of that year. The ironwork was added in 1875. The first record of a bridge here was in 1314 when the township of Sowerby was charged with failing to keep it in repair.

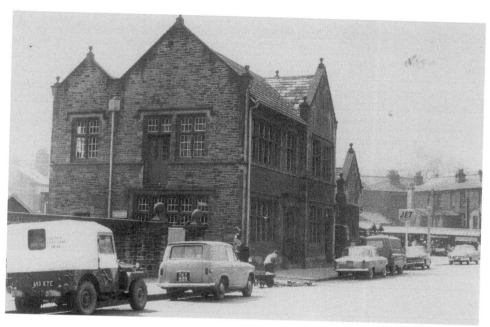

Station Road, 29 May 1963, showing the old post office, built in 1923, with its sorting office at the far end. There was public outcry when this purpose-built facility was closed down and the post office moved to a shop on Wharf Street, where parking is much more difficult. The building is now occupied by Mercer Electronics. Further along the road can be seen the open-air market and the former Jet garage. Has the young police officer found an out-of-date tax disc?

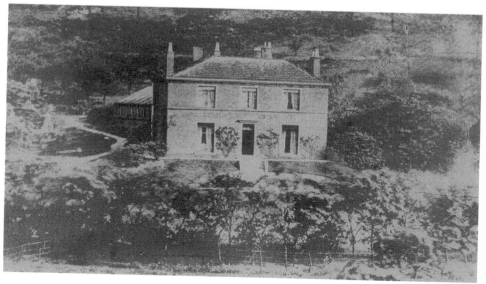

Allan House and grounds, 1865. The estate was purchased from Mr John Stansfeld in 1920 and made into a park. During much unemployment in 1922 many men found work laying out the park with a bowling green and swings. It was opened by Mr G.R. Stansfeld in May 1923. £2,100 of the £3,200 costs went in wages.

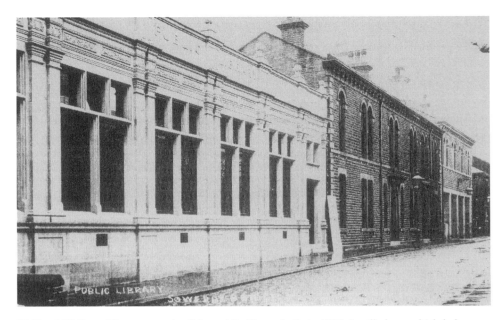

Hollins Mill Lane. The stonework of the public library, built in 1905, is still clean, which helps us to date this photograph in the early twentieth century. The library was built with funds provided by Andrew Carnegie, a Scot who had made his fortune in the USA and who supported many philanthropic projects. Further along the lane can be seen the public baths and council offices, built in 1878–79, and beyond that is the fire station, built in 1904.

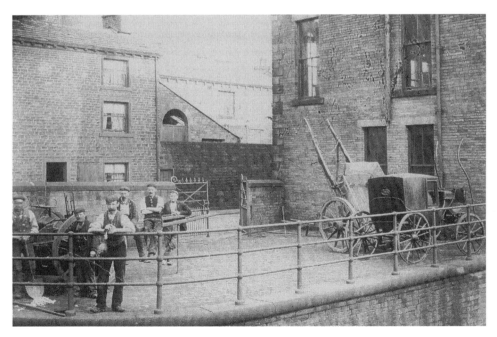

The site of the fire station, Hollins Mill Lane, *c.* 1902. The cab in the corner is the council's fever cab, used to transport patients suffering from contagious diseases.

Town Hall Street, 1868, showing Sutcliffe's Family Foreign Wine and Spirit Stores. At this time the road was still a toll road and the gates and toll bar in the bottom left-hand corner of the photograph were located there to catch traffic joining the road from old Tuel Lane (now Tower Hill). The large building with the chimney is the former works of Pollit and Wigzell, who were manufacturers of steam engines. In more recent times the Sutcliffe building has been a branch of Barclays Bank (recently closed).

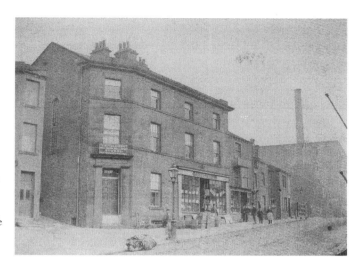

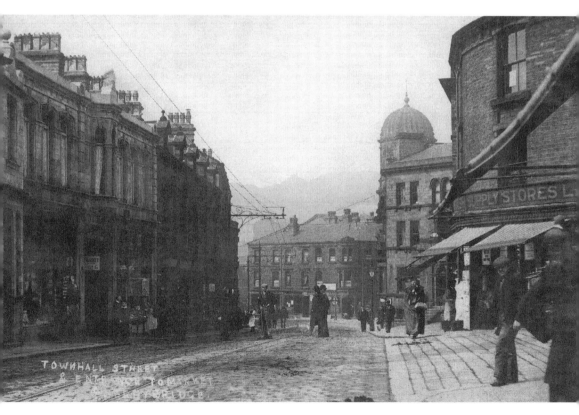

Town Hall Street at its junction with Tuel Lane (now Tower Hill). On the right at Nos 25–27 are the Cash Supply Stores Ltd, grocers, provisions and druggist and opposite is the indoor market and penny bazaar. A policeman can just be made out standing in the middle of the street talking to a man wearing a cloth cap. They would not be able to stand there in today's traffic!

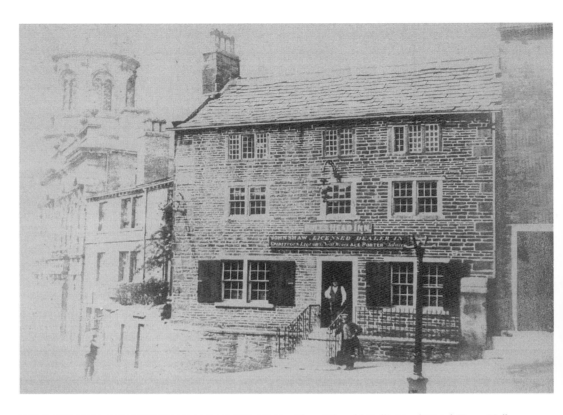

Above: The old Bull's Head Hotel, Town Hall Street, taken between 1857, when the town hall was built, and 1863 when the pub was demolished to make way for the present Bull's Head. The name board shows that the landlord was John Shaw, licensed dealer in spirits, liquors, ale and porter.

Left: An advertisement from *The Sowerby Bridge Chronicle,* dated 14 December 1894.

Opposite above: A view from the bottom of old Tuel Lane (now Tower Hill) across the junction of Town Hall Street and Wharf Street, showing the old indoor market and penny bazaar. At this time there was a cafe above, but most locals will remember this floor of the building being used for the local YMCA.

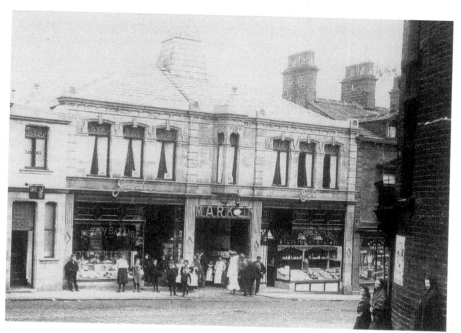

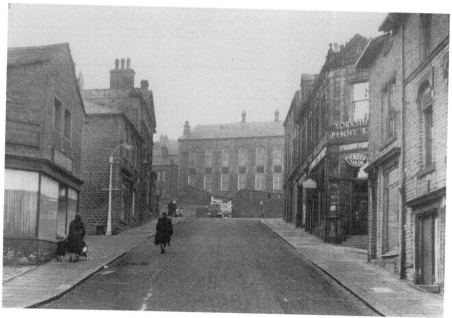

Looking up Tuel Lane (now Tower Hill) in 1956. This was once the main link to Burnley Road and the upper Calder valley and many road accidents happened here due to vehicles running out of control down the steep (1:8) hill. The situation was remedied by the building of a new stretch of road which filled in part of the disused Rochdale canal and joined Wharf Street near Christ Church. The Yorkshire bank was converted into a restaurant (now closed) and the United Methodist Free Church further up the road was burned down in 1988 to be replaced by the present St Paul's church.

Chapel Street, once a rather notorious part of the town. This and adjacent streets were demolished in 1965 to make way for the twin tower blocks of Ladstone Towers, named after a rocky outcrop on Norland Moor, and Houghton Towers, named after Lord Houghton, MP for Sowerby.

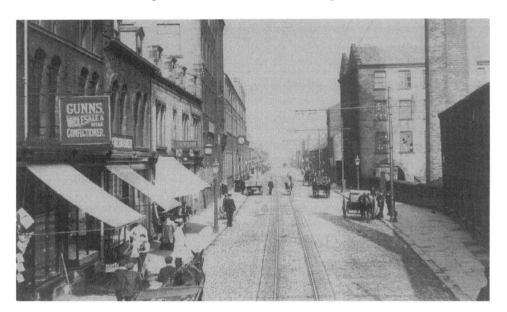

Wharf Street, 1910, looking towards Bolton Brow. Joseph Jackson, pawn broker and jeweller was at No. 11 and his pawnbrokers sign of three brass balls can be seen hanging below his name board. Just beyond this can be seen the lamp over the door of the Branch Inn. Then came the big factory of Siddall & Hiltons Ltd, bedstead and mattress manufacturers, and Pollitt & Wigzells, engineers and millwrights, with the tall department store of William Haigh in-between them. On the other side of the street are Longbottoms and Carlton Mills, parts of which date to the eighteenth century. It was the first integrated textile mill in Yorkshire; in other words, all the processes were carried out on one site.

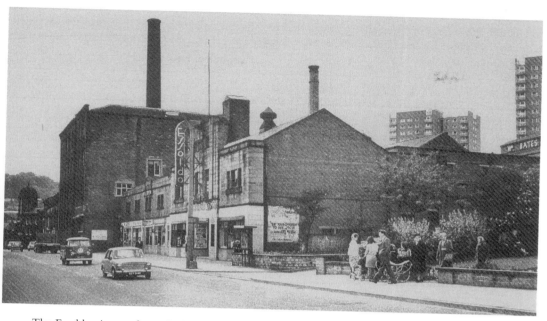

The Essoldo cinema, formerly the Regent, of Wharf Street, was built on the site of the former works of Pollit & Wigzells in 1939. The Essoldo and the nearby Roxy cinema, formerly the Electric, provided many hours of entertainment for local people. The Roxy is now a bingo hall and the Essoldo was partially demolished to become a nightclub, which is now closed. The cinema part of the Essoldo, at the rear, is now a public car park, and there are plans to relocate the open-air market here.

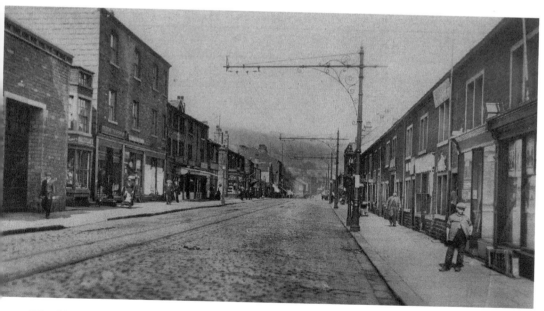

Wharf Street from a postcard dated 1923. Of interest on the left is the large doorway of Pollit & Wigzells factory and next to it is Halstead's shop, a very old and unusual premises which was demolished that year to make way for the new branch office of the Halifax Building Society.

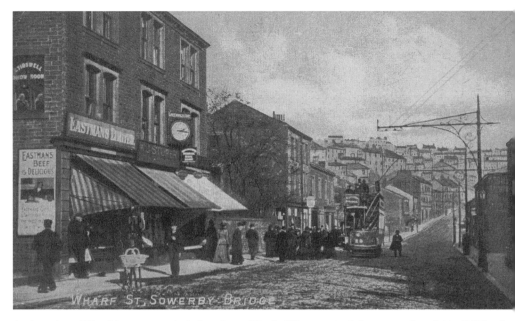

A view along Wharf Street towards Bolton Brow. The building on the left was numbered 41–47 Wharf Street. No. 41 was Thomas Tidswell, cabinet maker, house furnisher and undertaker, No. 43 was Eastman butchers; then came W.J. Storer, draper and hosier, and at No. 47 was F. & J. Shackleton, watchmakers, jewellers and opticians. Shackleton's clock, labelled 'Greenwich Time', can be seen above the shop.

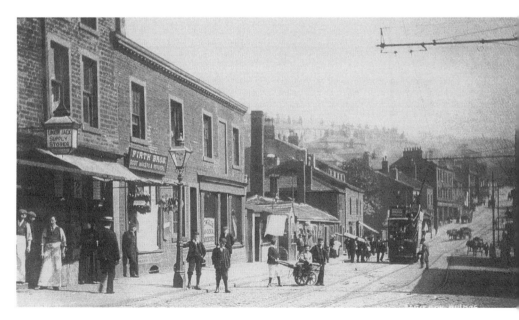

Wharf Street, 1905, near the bottom of Bolton Brow. Passengers board the tram for Halifax. Firth Brothers, boot makers and repairers were at No. 55. Extra horses were often needed to pull loads up Bolton Brow and a certain Mr Bolton (whose family lived locally and gave the area its name) was often to be found at the bottom of the hill with his 'chain' horses for hire.

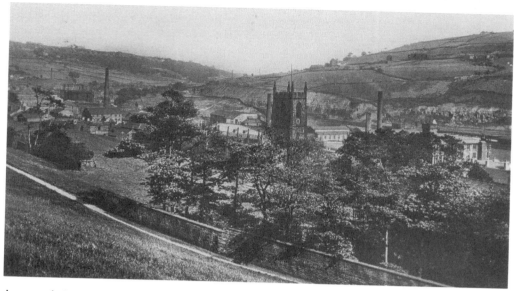

A postcard view sent from Sowerby Bridge to Morecambe, 11 September 1915. On the right the railway line can be seen cutting deep into the Norland hillside, which necessitated the building of the bridge to carry Fall Lane over it. Of greater interest, however, is the country aspect of Church Bank before Tuel Lane was diverted and the council flats and maisonettes were built here. It seems a very pleasant path to take a stroll on in those days.

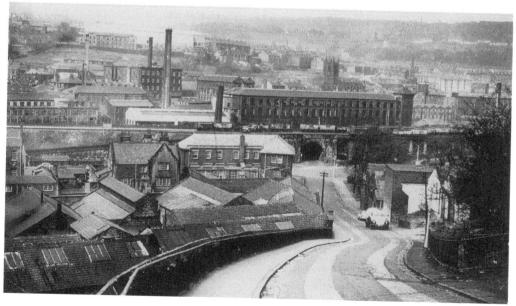

A view seen from Norland Road in 1962. The building on the left at the bottom of the hill is the old labour exchange which was built in 1932 and is now the police station. Next to it is the old police station, built in 1894, which is now a doctors surgery. Christ Church can be seen behind Dugdale's Valley Mill, and William Bates & Co Ltd in the top left has recently been demolished to make way for a new supermarket.

The river Calder at Mearclough. This area was originally known as Mearclough Bottom and a corn mill was located here as early as 1300. The Waterhouse family of Skircoat operated the mill for nearly a hundred years and then sold it to a family named Walker, a name preserved in the nearby Walker Lane. In the early industrial era the river was heavily polluted with chemicals and dyestuffs discharged from the mills and factories. A fishing inspector reports in 1865 how he fell into the river and his clothes were dyed blue, which 'defied the power of bleaching to obliterate'. On the skyline can be seen Wainhouse Tower at King Cross, which was built in 1875 as a mill chimney but was converted into an ornate viewing platform reached by a spiral staircase.

A view up the river Calder from near Canal Road. In the foreground is the eighteenth-century Mearclough bridge which connected the old townships of Skircoat to the right and Norland to the left. The buildings on the left of the bridge once housed the Lilywhite Postcard Co. The gasworks can be seen in the distance; in 1911, the cost of gas in Sowerby Bridge was 1s 9d per 1,000 cubic feet, and in the out-districts 2s 4d.

two

The Nook

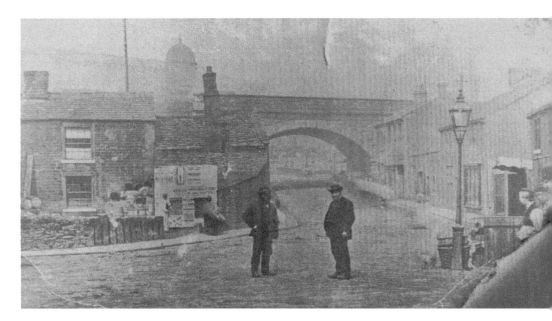

This area of the town, from the bottom of Sowerby Street to the railway viaduct, has been known as The Nook for a long time. The viaduct carried the original Lancashire and Yorkshire railway over the road and was built around 1840. It was later widened. Beyond can be seen the tower of the town hall. The photograph was taken in around 1875.

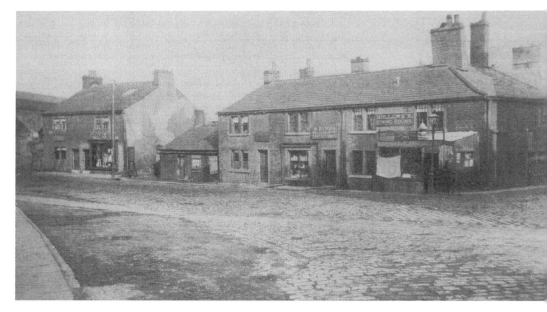

Another view of The Nook but showing the other side of the street and taken from the bottom of Sowerby Street, *c.* 1880. Hollow's dining rooms feature prominently on the corner, with Binns' wholesale confectioners next door. This whole block was demolished and replaced by the present Ryburn Buildings in 1884.

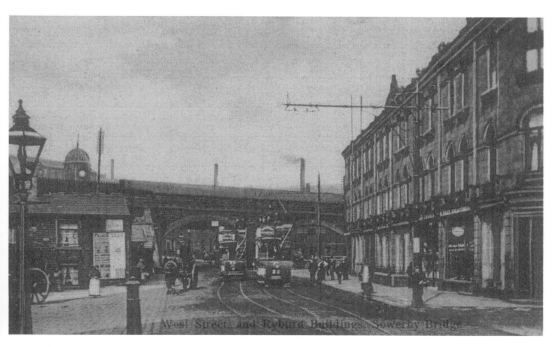

This view from outside the Royal Hotel shows the newly erected Ryburn Buildings. The tram line to Triangle was single track but had passing places at various points such as this.

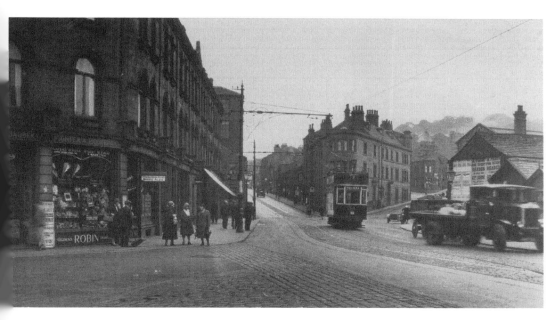

A view in the opposite direction, with West Street heading off in the centre, Station Road to the left and Sowerby Street climbing to the right, *c.* 1936. The Ryburn dining rooms, serving Shire ales, is still a cafe to this day. Behind the tram stands the Royal Hotel, originally called The Royal Commercial and Family Hotel and Posting House. This area was flooded in 1946.

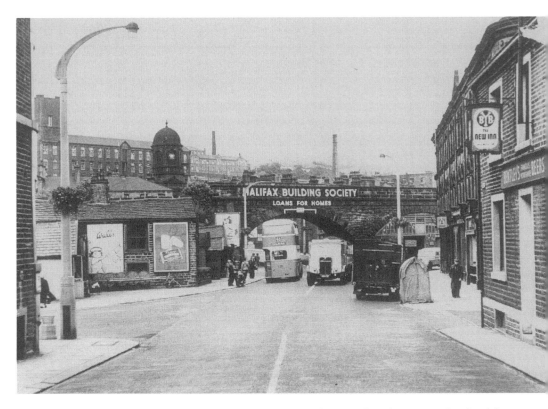

Another view of The Nook, this time from West Street, 1964. The trams have long gone. On the right is the New Inn, a Bentley Yorkshire Brewery pub which has now had its name changed to The Long Chimney, a local nickname for a mill chimney standing next to Rochdale Road at Triangle, about half a mile away. In the distance can be seen the smoke-blackened tower of the town hall, with Morris's Mill on Corporation Street behind.

Demolishing the old blacksmith's shop at The Nook in 1957. Ryburn Buildings can be seen in the background. The blacksmith's shop had been in use as such for over 100 years but due to the decline in customers and other factors the blacksmith, Mr Jack Greenwood, moved the business to his farm at Mill Bank. He was one of only nine remaining blacksmiths in the Halifax area. Mr Greenwood had been in business since 1946 but the number of horses being brought for shoeing had fallen from 200 to about twenty or thirty a year.

West End and Quarry Hill

The Woolpack Inn, West Street, at the junction with Foundry Street, when John Linton was the landlord. The huge lamp above the door can be seen in other photographs of the street. The pub at this time sold Webster's Fine Ales – 'The Beer that Cheers'. The establishment offered first class piano playing on Friday, Saturday and Sunday nights, as well as 'motor accommodation'. The following poem was used to extol the pub:

Websters beer it is a treat,
You can find no better in the street,
You may go up, you may go down,
You will find no better in the town.

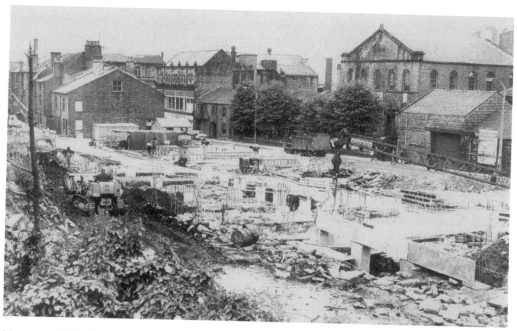

New council flats being built in West Street, 1964. The large building in the background is the former West End Congregational church which was later demolished, to be replaced with a petrol station. However, the petrol station has recently closed and housing is planned for the site. The large building in centre rear is the former furniture department of Sowerby Bridge Co-operative Society.

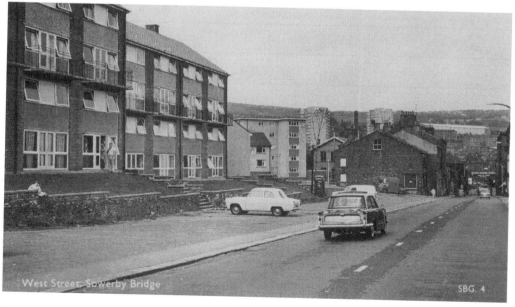

West Street, showing the block of flats under construction in the previous view. Incredibly, these flats only lasted for forty years and have recently been demolished to make way for new housing. The site currently looks as it did in the previous view.

A view of West Street, with the Co-operative Society shops on the left and the large lamp of the Woolpack Inn beyond, *c*. 1936. The ball of the left-hand Belisha beacon is missing – they were always a target for drunken vandals. West Mills dominate the lower part of the street and the photograph must have been taken after 1934 as the tram poles have been converted into street lights. Arthur Barraclough, newsagents, is on the right at No. 13.

Opposite above: The old Stirk bridge being taken down in 1859 and one of the earliest known photographs of Sowerby Bridge. The present Stirk bridge was built with open balustrades to let flood water pass through. A ducking stool was erected near here in 1685-6 to punish scolding wives, brewers of bad ale and bakers who gave short measure.

Opposite below: The Castle Inn, Broad Street, 1956. This was another Ramsden's pub and I have no doubt that many readers still regret, as I do, the demise of Ramsden's Stone Trough Ales. The inn was demolished along with the general clearance of this area of West End (known locally as Bogden), in order to build new housing. Broad Street no longer exists.

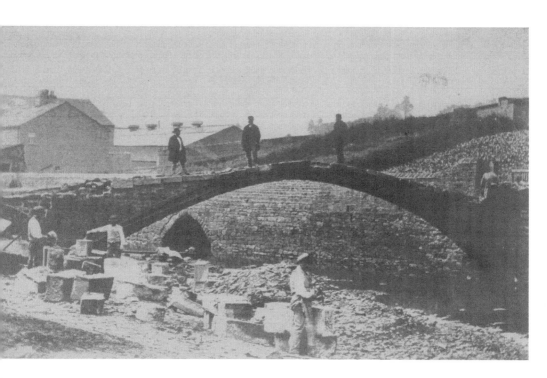

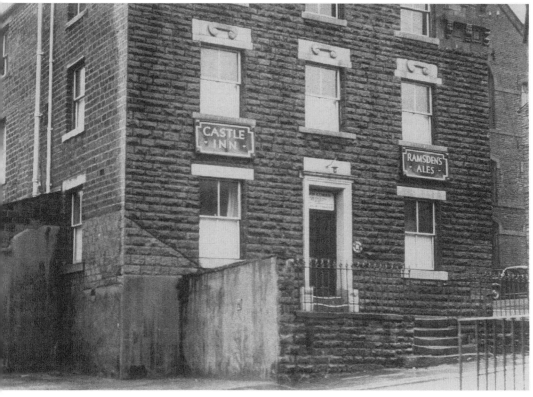

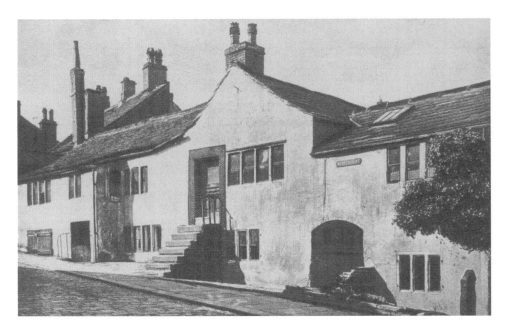

Old House and ginnel (passage) to Woods Court, Quarry Hill, as they were before the 1927 clearance scheme. The old Pear Tree Inn stood just above this house and it was there that Branwell Bronte, of the famous Bronte family of Haworth, lodged while he was employed for twelve months, in 1840–41, as a clerk at Sowerby Bridge railway station.

A view looking up Quarry Hill. The Royal Oak pub and the buildings on the right still survive but those on the left have long since gone. Before the turnpike (Rochdale Road) was built in 1740, this was the main route from Lancashire and was part of the salt route from Chester to York. It was previously called Pyghill Street.

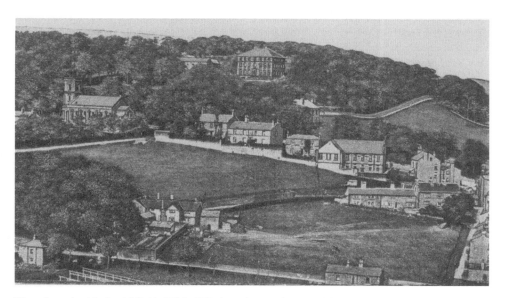

View from the Norland hillside. White Windows is near the top of the hill and to the left is St George's church which is now divided into flats. Quarry Hill descends diagonally to the right from the church and the fourth building down is the former St George's School which is now converted into dwellings. In the bottom left-hand corner is the old toll house at the junction of West Street and Watson Mill Lane, and to its right is Asquith Bottom Old House on Syke Lane. White Windows, built in 1767 by John Priestley, became a Cheshire home for the disabled and chronically sick in 1957.

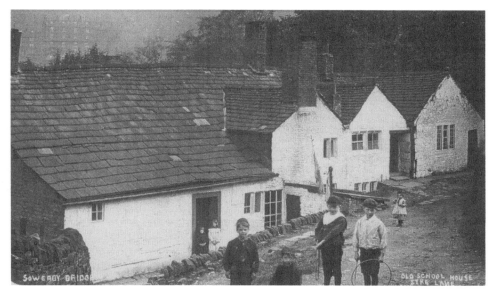

Old School House, Syke Lane, off Quarry Hill. Also known as Asquith Bottom Old House, this building dated to the Tudor period and was one of the oldest buildings in Sowerby Bridge until it was demolished in 1956. It is first mentioned in 1556 when it was owned by the Waterhouse family of Lower Hollins, Warley. It had a date stone of 1171 but most historians agree that this was probably reused from an older building.

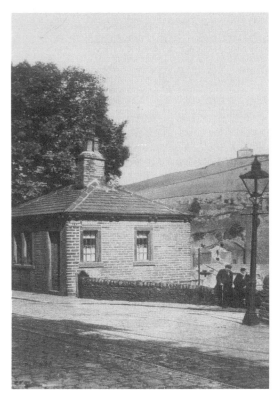

Left: Ye Old Bar House, at the junction of West Street and Watson Mill Lane, *c.* 1906, was strategically placed to collect tolls from any traffic joining at this point. The toll gates were taken down in 1872 and the last person to pay the toll here was a horse dealer with about a dozen horses. The toll house was demolished in the late 1980s.

Below: A postcard, view, dated 1917, of Belmont, Rochdale Road. The tram is heading for the terminus at Triangle. Belmont Terrace on the right was demolished some years ago. The tram service reached Sowerby Bridge in 1902 and was extended to Triangle in 1905. The Triangle service ceased in 1934 and was followed by the Sowerby Bridge service in 1938.

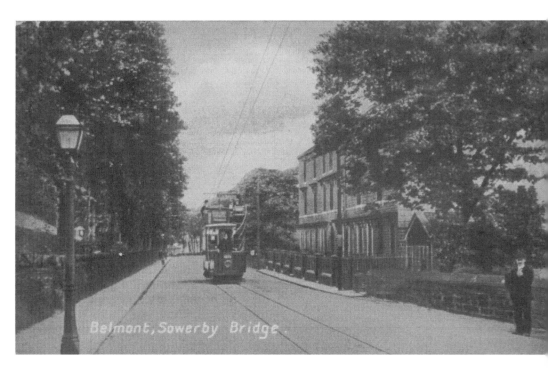

Belmont, Sowerby Bridge.

four

Bolton Brow
and
Pye Nest

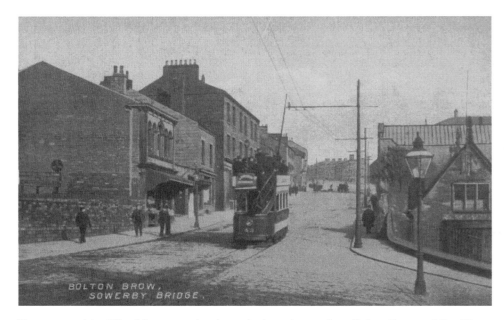

Tram approaching Wharf Street, coming down the long descent from Bolton Brow and Pye Nest to King Cross. Of interest in this photograph is the building on the right which once served as the town's police station. The tram service was extended to Sowerby Bridge in 1902.

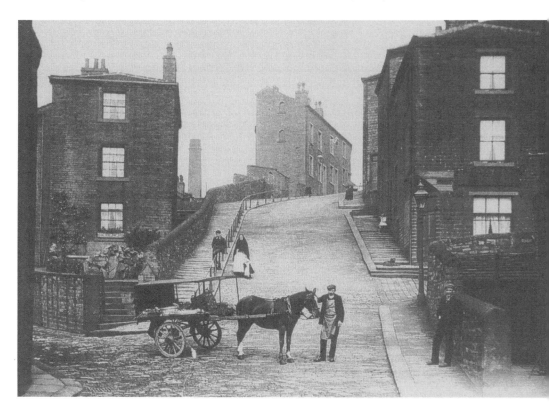

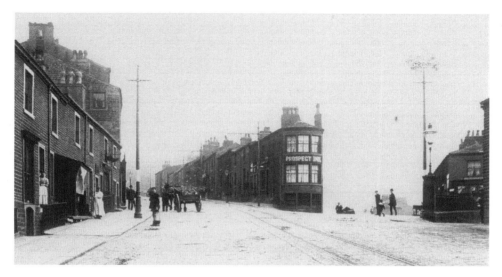

View looking up Bolton Brow. The Prospect Inn, standing at the junction with Wakefield Road, is now the Prospect veterinary surgery. At one time there was a great choice of public houses in Bolton Brow but long gone are The Brown Cow, The Queen Hotel, The White Lion and The Oddfellows. In 1905 there were thirty-seven pubs and six clubs in the town.

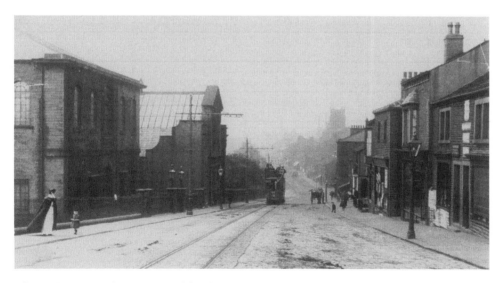

Above: This view is from a postcard dated 1908. The first buildings on the right-hand side of the road still survive but the ones lower down have been demolished. Bolton Brow chapel and Sunday School are on the left.

Opposite below: Clifton Street, Bolton Brow, nicknamed 'Spion Kop' by older generations after an infamous battle during the Boer War of 1899-1902. In this action, British troops had occupied the top of a steep hill during the darkness of a misty night only to find at daybreak that they were over-looked by the Boers on an even higher hill. The British soldiers attempted to dig trenches in the rocky ground but suffered appalling casualties from the Boer rifle fire. With a gradient of 3.7, it is the steepest street in the town and, not surprisingly, is now closed to traffic.

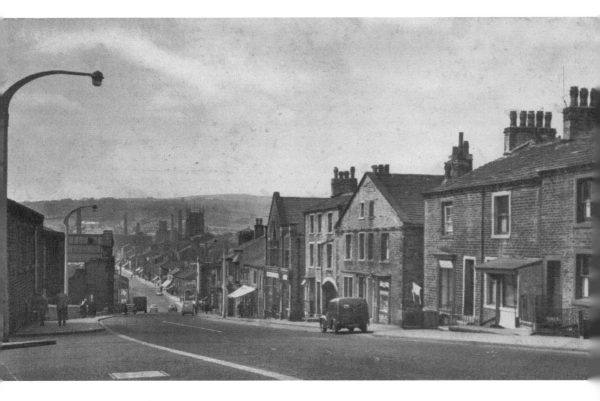

A Lilywhite postcard showing the view down Bolton Brow from another angle. Lilywhite started up in business at Mill Bank, Triangle, then moved to Mearclough, Sowerby Bridge, and then to Brighouse.

Opposite above: View of the left-hand side of Bolton Brow when looking downhill towards the town centre. This was taken on 24 July 1964 when many of the properties were being demolished.

Opposite below: Young children play in the grounds of St Patrick's Roman Catholic church, Bolton Brow, in 1956. The site was originally called Broad Gates as early as 1454 when it was owned by Robert Wainhouse. The old house was mostly rebuilt in the 1850s by its new owner Sir Henry Edwards and its name was changed to Underbank. The estate was purchased in 1918 by the Roman Catholics who at first converted the old house into a church. This soon proved inadequate and a new church was opened on 16 October 1934.

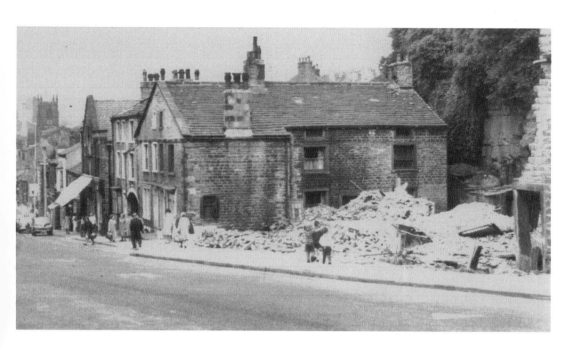

Left: Lower Willow Hall gatehouse, Willow Hall Lane. Lower Willow Hall was built in 1608 by Samuel King of King Cross and the gatehouse was added 1630–1640. The hall itself was demolished and rebuilt in 1792. The road has been raised considerably and the gateway has been converted into a downstairs room.

Below: The Crow Wood V.A.D. (Voluntary Aid Detachment) Hospital, Sowerby Bridge. Crow Wood House was opened up as a temporary hospital on 25 April 1917, during the First World War, for convalescing soldiers and had accommodation for fifty patients. Day duties were performed by the V.A.D., and night duties by the 8th Battalion West Riding Volunteer Ambulance. The commandant was Matron Gowing.

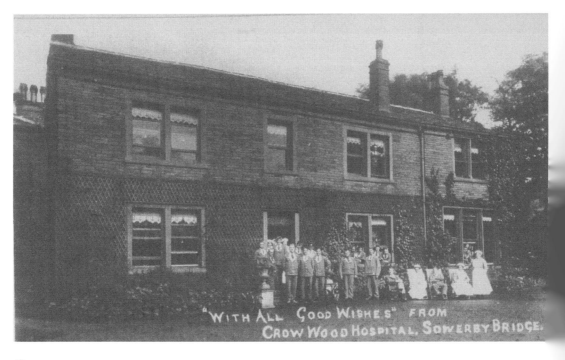

"WITH ALL GOOD WISHES" FROM CROW WOOD HOSPITAL, SOWERBY BRIDGE.

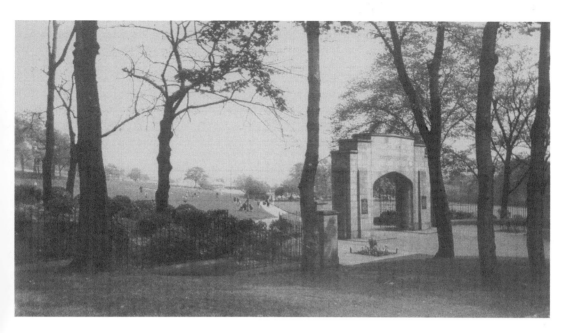

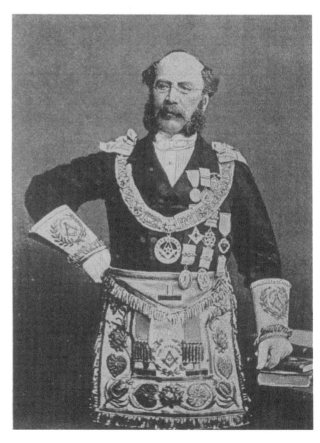

Above: Sowerby Bridge war memorial stands in the form of a gateway at the entrance to Crow Wood Park, Pye Nest. Crow Wood House and 9,450 square yards of land were purchased from Mr W.P. Eglin just after the First World War for £1,650, and further land was acquired from major A.H. Edwards of Pye Nest House. The park was opened on 14 April 1923 and the memorial arch and gates were unveiled on 10 November 1929.

Right: Sir Henry Edwards, CB, in his freemason regalia as Provincial Grand Master for West Yorkshire, 1875-1885. The Ryburn Lodge of Freemasons (No. 1283) had its headquarters at 'Eaglescliffe', Beech Road, Sowerby Bridge from 1869.

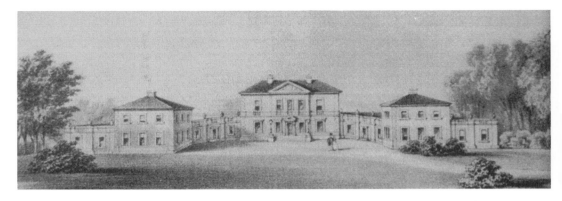

The Edwards family lived at Pye Nest mansion which was located roughly where Pye Nest gardens is today. The Pye Nest estate had existed from at least the seventeenth century, having at times been owned by such influential Halifax families as the Wainhouses and the Listers. The estate was bought in the middle of the eighteenth century by John Edwards and the mansion was completed by 1768. The Edwards family also owned Canal Mills on Wakefield Road. The estate was bought for housing in the 1940s after the mansion had been demolished in 1935.

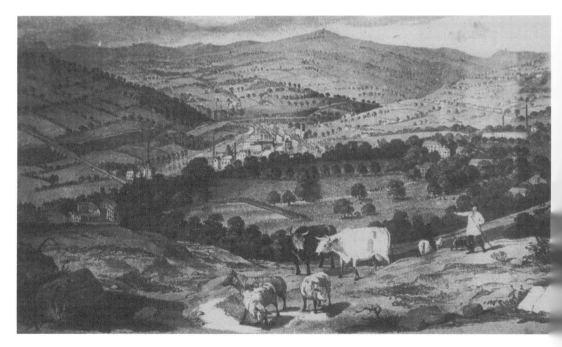

View of Sowerby Bridge, drawn by A.F. Tait in 1845, looking down over Pye Nest from King Cross. It is still basically a rural scene but for the clusters of mill chimneys along the river Calder in the valley bottom. Early textile mills were powered by water wheels and later by steam engines fuelled by coal brought in by canal and railway.

Burnley Road and Luddenden Foot

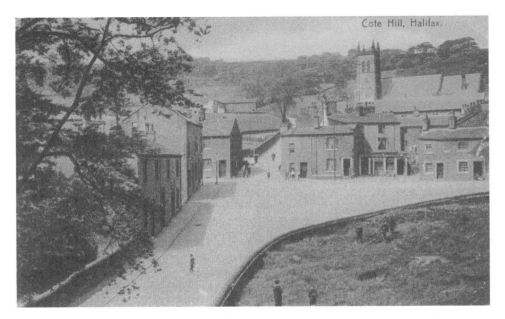

A postcard of 1909 showing the junction of Burnley Road and Gratrix Lane at Cote Hill. The scene looks very different today as most of these buildings have been demolished. The Rose and Crown Inn stands between the buildings on the right.

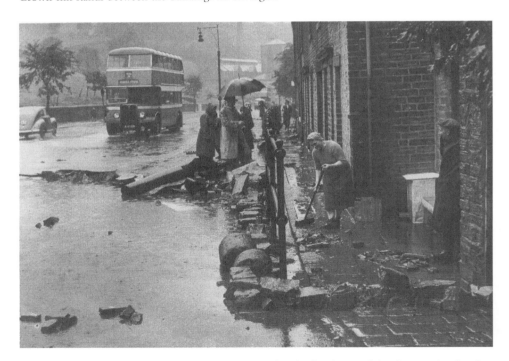

Glenfield, Burnley Road, August 1954, cleaning up after the floods. A Halifax Corporation bus in its livery colours of green, cream and orange passes by on its way to Hebden bridge. These houses have now been demolished.

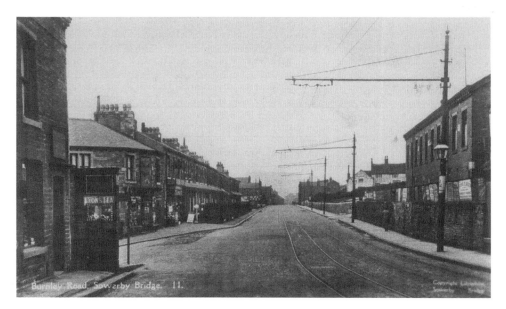

Burnley Road at the top of Tuel Lane. Friendly Snooker Club is on the right with the old whitewashed properties on Blackwall Lane beyond. The tram service extended as far as Hebden Bridge.

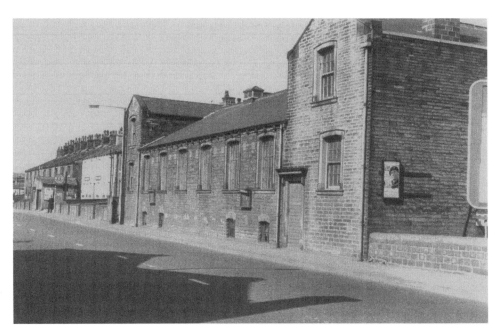

The former Drill Hall, built in 1912, which stood on Burnley Road opposite what is now the Hillcrest garage. The hall was demolished some time ago and the plot is now a private garden. 'H' Company, of the 4th Battalion Duke of Wellington's (West Riding) Regiment, were based here and went to war in 1914 commanded by captain W.A. Laxton. The other companies were based in Halifax, Brighouse, Elland and Cleckheaton. The public house in the background is the White Horse, a Ramsden's pub in those days.

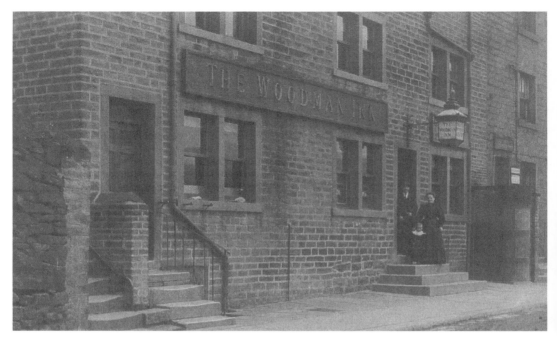

The Woodman Inn, Burnley Road, Luddenden Foot.

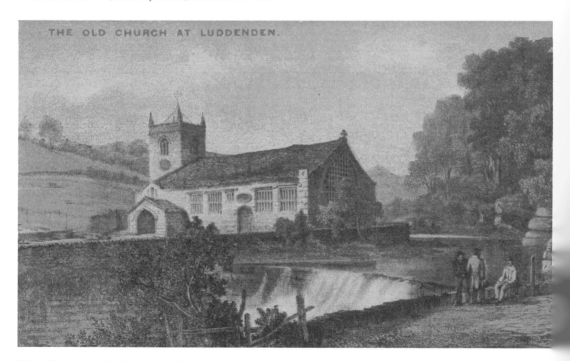

The old church at Luddenden. This is the second church on the site and was built in the sixteenth century and consecrated in 1624. The tower was added in the eighteenth century. By 1804 the church was in a poor state and the decision was taken to demolish and replace it with the present St Mary's.

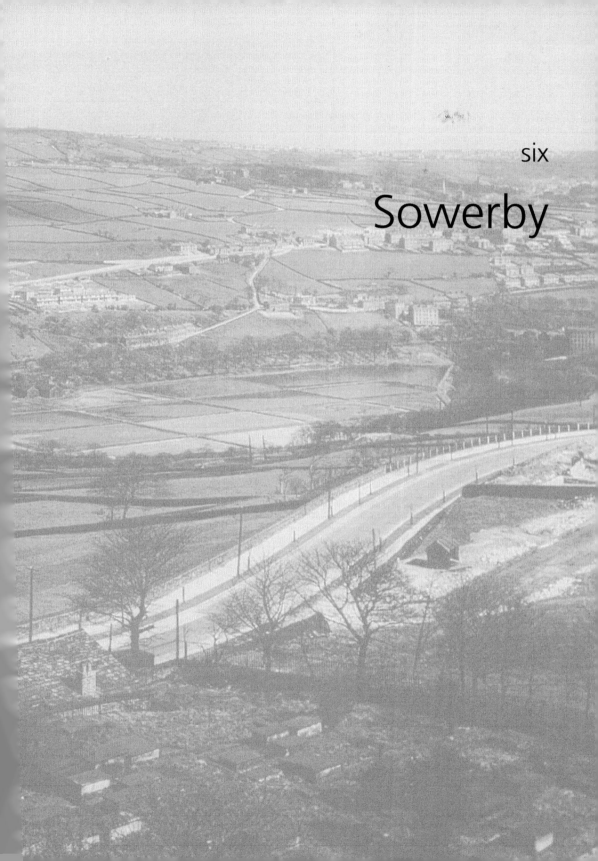

six

Sowerby

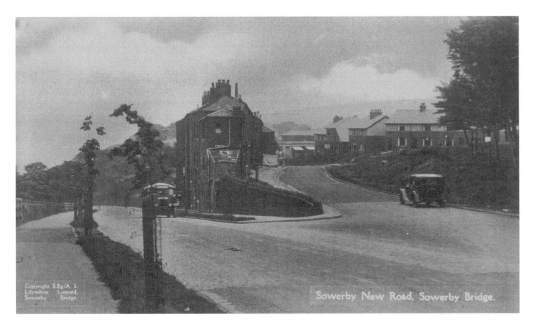

Sowerby New Road at its junction with Fore Lane, *c.* 1930. A single-decker bus is travelling towards Sowerby.

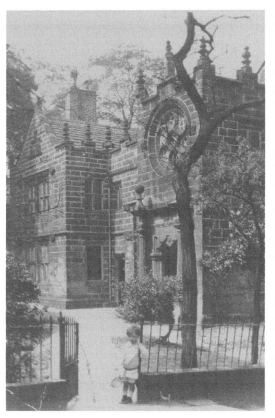

Left: Wood Lane Hall in Sowerby is a grade one-listed building. It was rebuilt by John Dearden in 1649, the year that Charles I was beheaded. It has an 'apple and pear' round window above the porch and one of its six bedrooms was turned into a replica of a ship's cabin by one of the later Sugden owners, who loved travelling by sea.

Opposite above: Interior of St Peter's church, Sowerby, showing the statue of Archbishop Tillotson by Joseph Wilson. The statue was commissioned by George Stansfeld of Field House, Sowerby, who presented it to the church in 1796. To its right is a plaque recording the deaths of ten Sowerby men who died during the Crimean War of 1853–1856. The plaque has since been moved to a different location in the church.

Opposite below: Interior of St Peter's church, Sowerby. The church is one of only three grade one-listed buildings in the Sowerby Bridge area. The present church was built in 1763–66 by John Williams and the interior was restored in 1880. The exquisite plasterwork was executed by an Italian, Guiseppe Cortese, in 1766. Sections of the former church can still be seen, re-erected as it is at Field House, Sowerby.

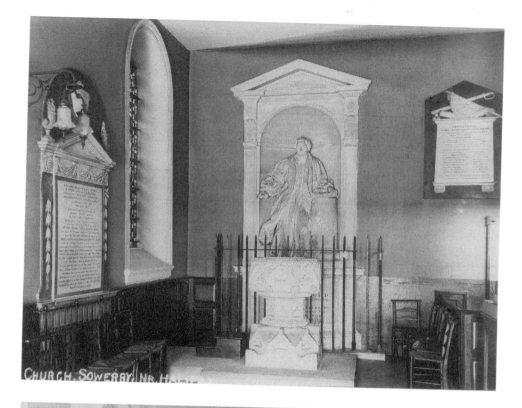

CHURCH. SOWERBY. NR. HALIFAX

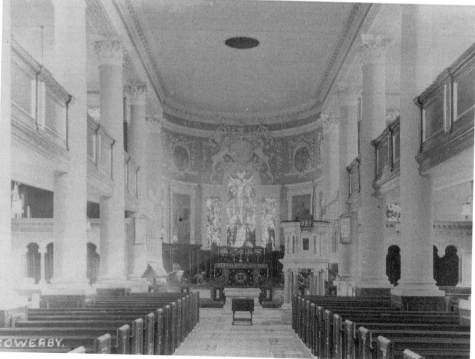

SOWERBY.

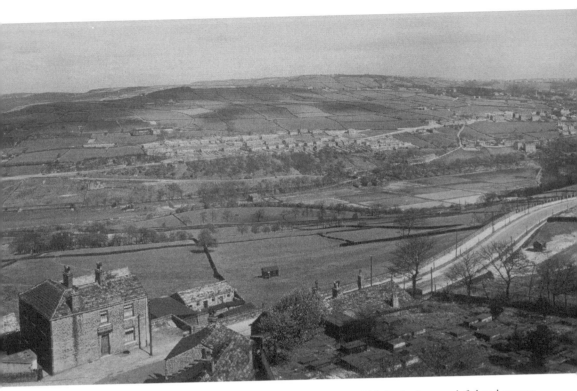

Postcard view taken from the tower of St Peter's church, Sowerby, 1938. In the bottom left-hand corner is the Church Stile pub and the newly widened and refurbished Sowerby New Road can be seen running off to the right. Pollit Avenue was yet to be built at this time.

Opposite above: Sowerby as it was; a housing estate now covers these fields. On the far right, the church with the spire is the Congregational church at Sowerby Green, built in 1861 and demolished in 1980. To its right is the Wesleyan chapel in Rooley Lane and below that is Rooley Lane Methodist Sunday School, built in 1877.

Opposite below: A view along Towngate, Sowerby, photographed from the tower of St Peter's church, 1938. On the left can be seen the ornate row of the Rawson almshouses, built in 1861, which are now replaced by a row of shops. The large building on the left is the former Providence Primitive Methodist chapel and higher up the village can be seen two other chapels, now all gone. Near the Congregational church (the one with the pointed spire), stood the Star Inn (now the Rushcart) which was owned, in the early nineteenth century, by John Whiteley, one time constable of Sowerby. His nickname was 'John Almighty' and he described himself as 'the lynx-eyed thief catcher'. He was admitted to the Halifax workhouse in about 1852 and died there in 1858, aged seventy years. Sowerby Hall is in the bottom right-hand corner and is still there today.

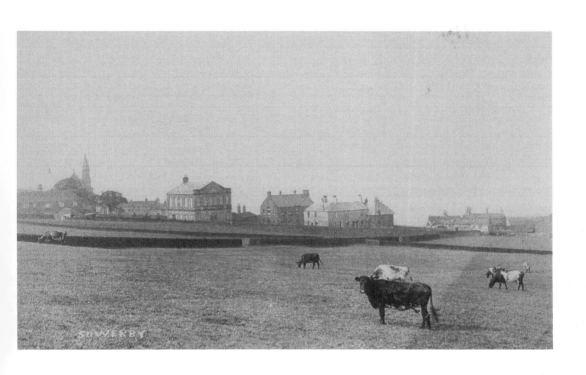

SOWERBY

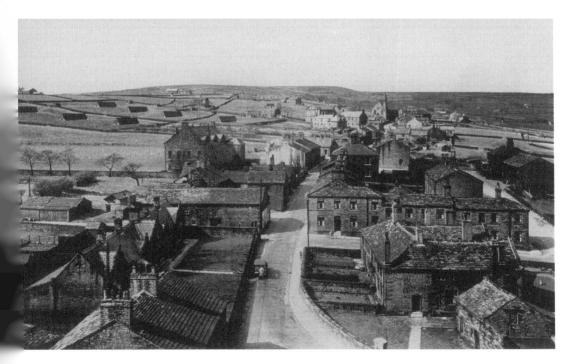

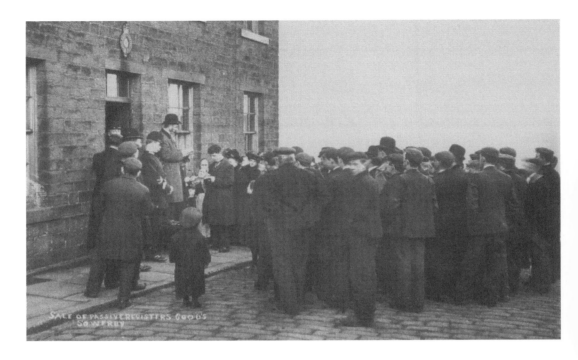

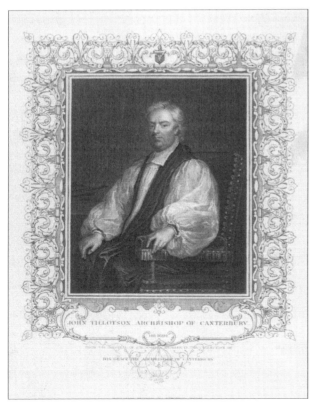

JOHN TILLOTSON, ARCHBISHOP OF CANTERBURY

Above: A crowd gathered outside the Police House, King Street, Sowerby. The plaque above the door is for the West Riding constabulary. The event is the sale of passive resisters' goods. These were seized from those who objected to payment of the Education Rate, which was required by the Balfour Act of 1902. Objectors were mainly non-conformists who were against paying taxes for the provision of Church of England schools. Many would rather go to prison than pay, and distraint was therefore made on such people's belongings.

Left: John Tillotson, Archbishop of Canterbury, who was born at Haugh End in Sowerby. There is a statue of him in St Peter's church, Sowerby. Born in 1630, he became Archbishop of Canterbury in 1690 during the reign of William and Mary. He married Elizabeth French, a niece of Oliver Cromwell, and was at one time chaplain to Charles II. He died on 22 November 1694.

Archbishop Tillotson's birthplace at Old Haugh End, Sowerby. In the time of Henry VIII, the house was called 'The Plattes' and was then owned by the Gaukroger family. Originally a timber-framed building, it was encased in stone in the eighteenth century.

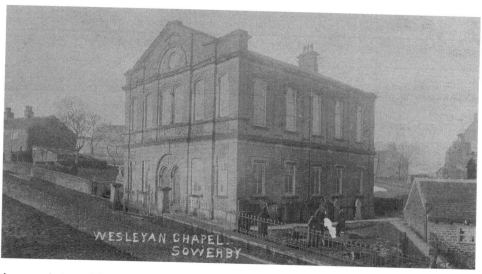

A postcard view of the Wesleyan chapel, Rooley Lane, Sowerby. The first chapel of 1787 was destroyed by fire in 1876. 'Many tears were shed and perhaps many a heart lost hope; however, a mighty zeal sprang forth and through much difficulty the present commodious Chapel and School buildings were opened in 1877'. One eccentric character who preached at the chapel, John Farrar, would often end his sermon with 'Well, if you sinners don't repent and come to Christ, you'll all go to Hell, rag tag and bobtail'.

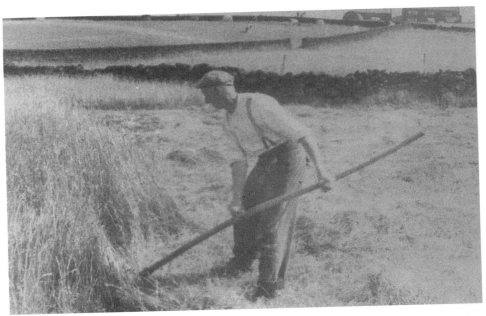

Mr F. Helliwell of Sands farm, Sowerby, photographed on 21 June 1957 whilst mowing by hand.

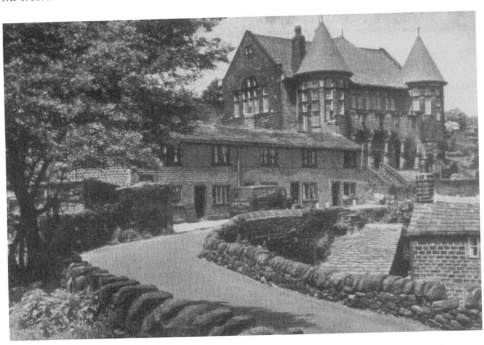

The Methodist church at Boulder Clough, *c.* 1900. Originally known as the Bethel United Methodist church, the church was built in 1822 but was replaced by the present church in 1898 in the style of the French Renaissance. The last service was held there on Sunday 30 September 1979, after which it was subsequently converted into a dwelling. The row of cottages, of which the left-hand one was a shop, have now gone.

seven

Triangle and Mill Bank

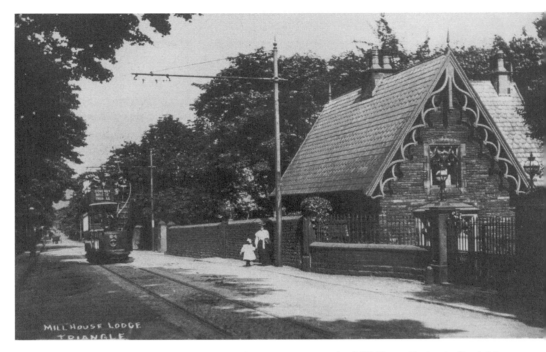

Tram No. 64 making its way towards the Triangle terminus, passes the Mill House Lodge in Rochdale Road, *c.* 1905. Mill House was the home of the Rawson family and has long been demolished. At this time the fare from Triangle to Sowerby Bridge was one-and-a-half old pennies. Tram No. 64 came off the rails and crashed at Pye Nest two years later.

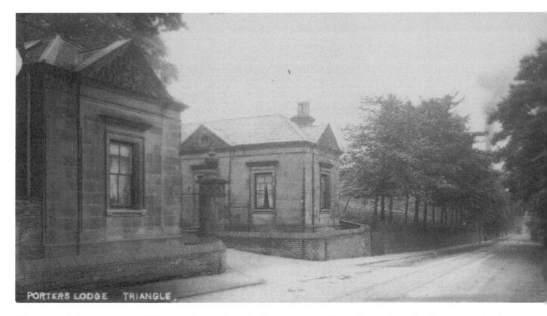

The porter's lodge for Field House, situated on the long drive to Dean Lane, Sowerby. It was originally built in 1749 and then rebuilt 125 years later. The lodge is situated on Rochdale Road, Triangle.

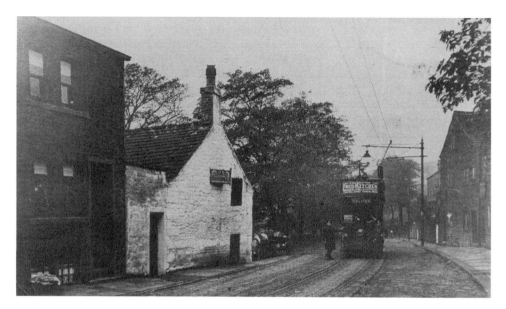

A tram waiting at the Triangle terminus before setting off back to Sowerby Bridge and Halifax. The white building on the left was handily placed to provide teas and refreshments to travellers waiting for the tram. It was once the Blue Ball Inn, which closed in 1910. There was another pub just out of shot to the left, called the White Horse, which closed in 1955 and has since been demolished. The landlord of the Triangle Inn at the other end of the village wanted the trams to go as far as his establishment but they never did and when the trams were discontinued he obtained the pole in the picture and had it erected outside his pub, where it still stands. The properties on the right have now all gone.

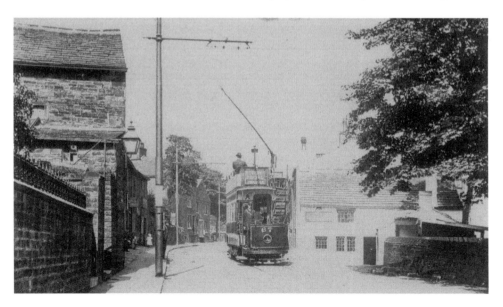

The Triangle tram terminus from the other side. The parcel office was located at the shop on the left. Triangle was originally known as 'Pond'; the present name comes from the triangular-shaped piece of land between the old turnpike leading to Ripponden and the road to Mill Bank.

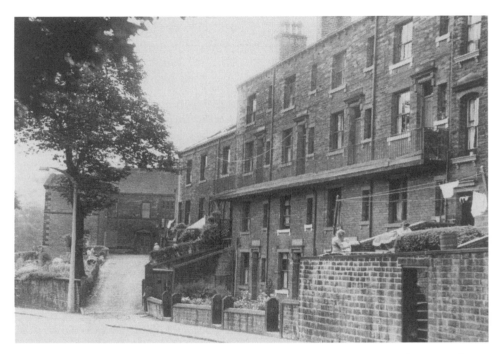

Centre vale and driveway to Hollin's House, 1955. The block of houses on the right are good examples of 'up-and-over' houses, which are fairly common to the district and designed to make the best use of the steeply sloping valley sides. Each house consists of two storeys, with the top houses being reached from a balcony which runs round the front and down the side of the building. The top houses are also back-to-backs, with Hollins Street behind.

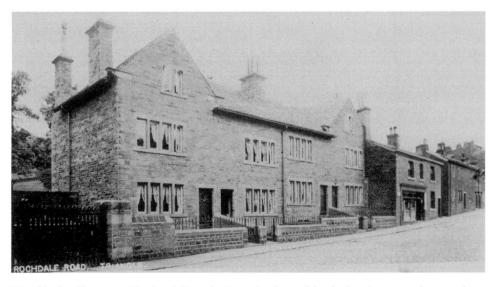

New block of houses at The Pond, Triangle. Over the door of the furthest house can be seen the West Riding police plaque as this was the local police house. Next door is the village post office which is still going strong but the next building along has now gone.

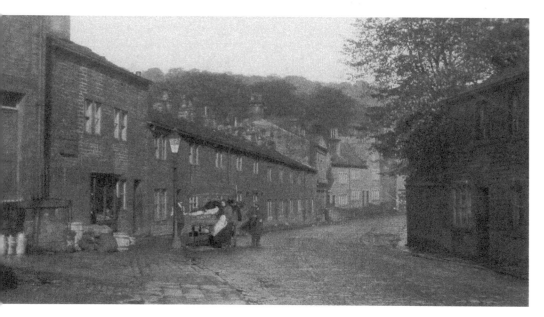

Main Street, Triangle, actually Rochdale Road. The road from Mill Bank comes down on the left. The Triangle Stores and the long row of cottages have long been demolished.

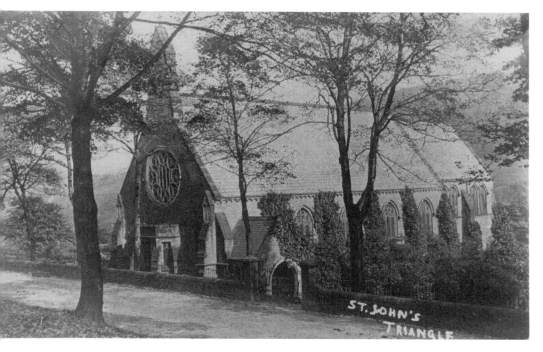

The Church of St John the Divine was built, in 1880, next to the main road at Thorpe, Triangle, at a cost of £7,000, in memory of Mr Frederick E. Rawson. It was badly damaged by fire on 15 January 1917 but was rebuilt at a cost of £13,000. It has since been demolished.

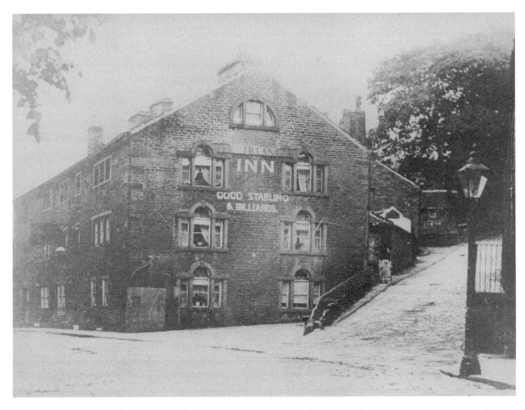

The Triangle Inn, which opened for business as a coaching inn in 1767 following the construction of the Halifax to Rochdale turnpike. This photograph was taken before the Triangle war memorial was fixed to this gable-end wall. The memorial was unveiled on 15 May 1920 by Major Stansfeld and records the names of twenty-five local men who died in the First World War. The road to the right goes up to Mill Bank.

TRIANGLE INN.
TO BE LET
WITH IMMEDIATE POSSESSION,
The Triangle
INN,
SOWERBY, in the Parish of Halifax,

Together with Waggonhouse, Stable, Brewhouse, &c. and about 26 Days' Work of LAND, lately occupied by Mr. GEO. BESWICK, deceased.

APPLICATION TO BE MADE TO

Mr. STANSFELD, of Field House.

January 1st, 1831.

A poster from 1831 advertising the Triangle Inn for let, following the death of its landlord, Mr George Beswick. At that time the inn was owned by Mr Stansfeld of Field House, Sowerby.

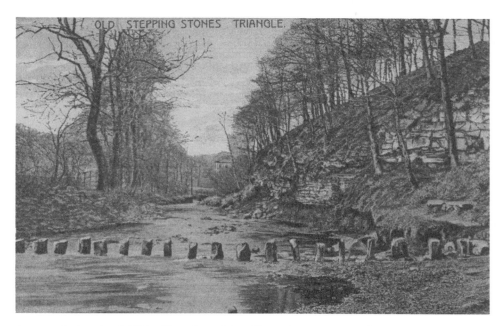

A postcard view dated 1914 with a view of the old stepping stones over the river Ryburn at Kebroyd, Triangle. The stepping stones were later replaced by the Alexandra footbridge

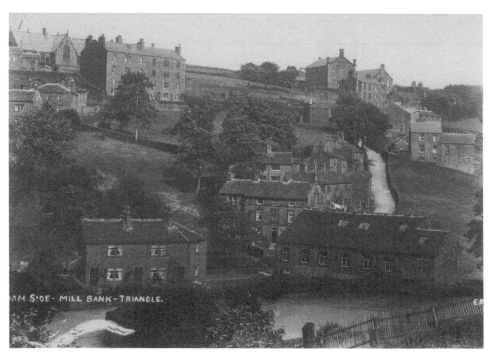

Mill Bank, Triangle. Bottom right is the small mill, once owned by Ryburn Knitwear, with its mill dam. Behind it, the building with the four chimney stacks was once the Blue Bell Inn, which closed in 1948. Top left is Mill Bank School and top right is the chapel.

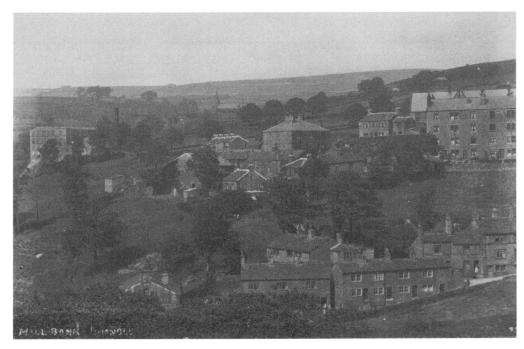

Another view of Mill Bank. Of interest here is Upper Lumb mill in the top left which was the first premises of the Lilywhite Postcard Co. until it was destroyed by fire in 1931. The company subsequently moved to Mearclough Mills, Sowerby Bridge. Local historians owe this company a great deal of thanks for recording the history of the area.

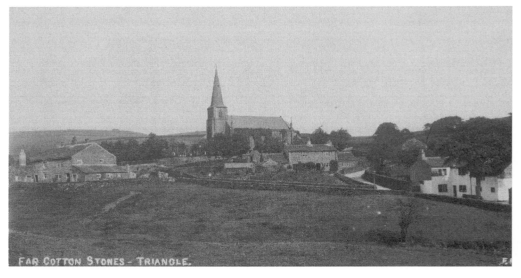

View of Far Cottonstones, Mill Bank, Triangle. The white building on the right, now Friendly Inn farm, was once the Friendly Inn. In the background is St Mary's church, which was opened on 8 May 1848 by the Bishop of Ripon and paid for by the Hadwens, a family of textile manufacturers at Cottonstones. The longest serving vicar was the Revd William Purvis who was there from 1896 to 1943.

Norland

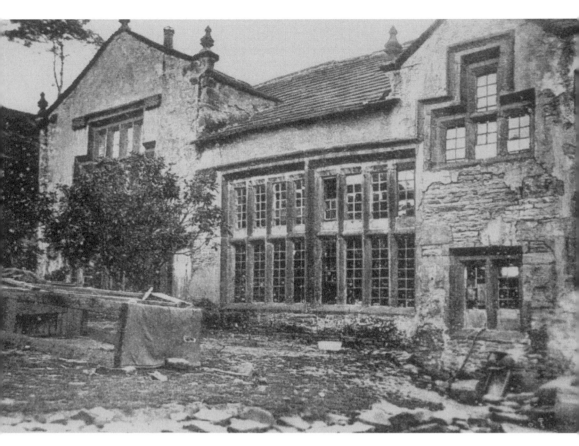

Norland Hall. The original building was wooden framed and built in the sixteenth century. In the seventeenth century it was encased in stone. The hall was struck by lightning in 1912 and this, coupled with long neglect, caused the roof to collapse and the building to become uninhabitable. The greater part of the building was dismantled in 1914 and was sold to the American newspaper tycoon Mr William Randolph Hearst, who intended to re-erect it on his ranch at San Simeon, California. It was shipped out in 812 large cases in 1922-3 but was never rebuilt, although some of the stonework was incorporated into a new Presbyterian chapel in 1967.

Opposite above: The Blue Ball public house, which has held a licence since 1862. The cottages on the left have now been incorporated into the pub.

Opposite below: The West Bottom Tavern, Hob Lane, Norland. An amusing story exists about a boast made in the tap room of the tavern by a local character who declared that he could push a wheelbarrow from the top of Watson Mill Lane to the tram terminus at Triangle faster than the tram could do it. Bets were laid and on the due day the man set off in front of the tram in the middle of the tracks, refusing to let the tram past, until he arrived at Triangle and collected his winnings. The tram driver's views are probably unprintable here! The pub is now called The Hobbit and has been greatly extended.

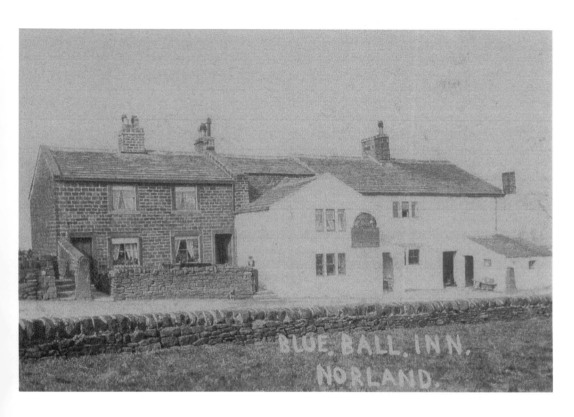

BLUE. BALL. INN.
NORLAND.

Norland village during the winter of 1955. St Luke's church, which opened on 6 March 1866, is on the right. Previously, it had its own vicar but today it is attached to Christ Church at Sowerby Bridge. On the left is the sub-post office. The wooden hut in the garden behind the telephone box was run as a sweet shop by a local lady for many years.

Textiles

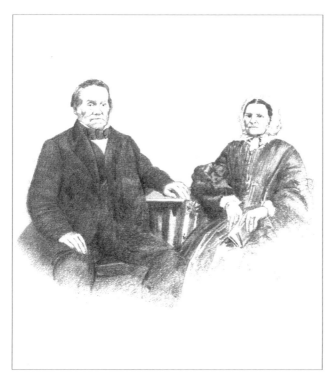

Left: John Atkinson, the founder of John Atkinson & Sons, with his wife Sally. The firm was originally located at Turvin Mill, Cragg Vale, but moved to Watson Mill (originally a corn mill) in 1855 where they concentrated on making blankets and uniform cloth for the British army. The company was granted its own coat of arms in 1959.

Below: Watson Mills, Sowerby Bridge, and the Norland Hillside, *c.* 1912. Of interest here is the railway line running behind the mills; this was the Ryburn Valley branch line which went up to Triangle, Ripponden and Rishworth stations. There was also a train halt at Watson Mills. Also of interest are the tenter frames in the field in the bottom right-hand corner. Cloth was stretched out on the frames to bleach and dry.

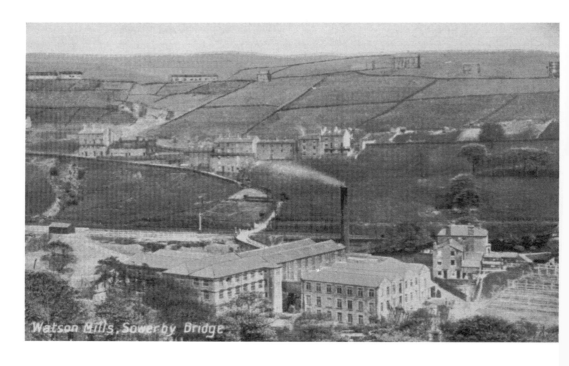

Watson Mills, Sowerby Bridge

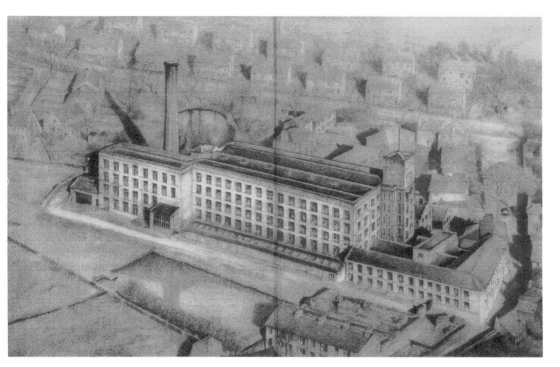

Willow Hall Mill was purchased by Atkinsons in 1920 and used for wool warehousing, carding and spinning processes while the weaving and finishing was retained at Watson Mills. The company exhibited at the British Industries Fair in 1932 when the stand was visited by Her Majesty, Queen Mary. In 1933, the company bought West Mills and the weaving department was moved there.

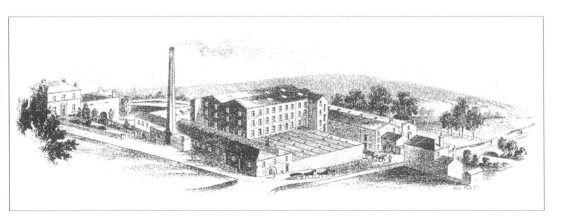

A drawing of Watson Mills taken from an 1890 trade directory. John Atkinson & Sons occupied these and other premises in the town for many years, producing fine and super wool blankets, costume, velour and dress cloths.

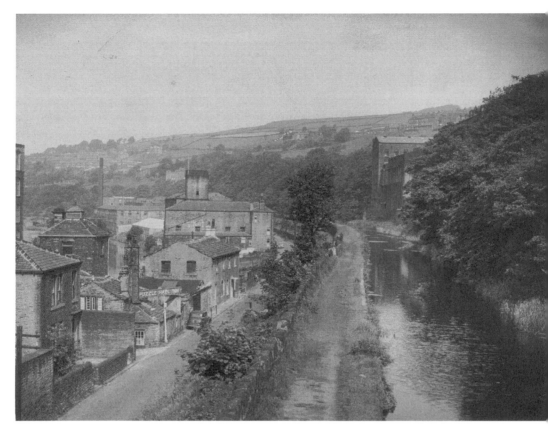

A view along Hollins Mill Lane, showing Holme Mills with the water tower and Hollings Mills beyond. This photograph was taken from the iron footbridge constructed by Sowerby Bridge Industrial Society over the Rochdale Canal. Of all the buildings shown in this photograph only the Puzzle Hall Inn still survives.

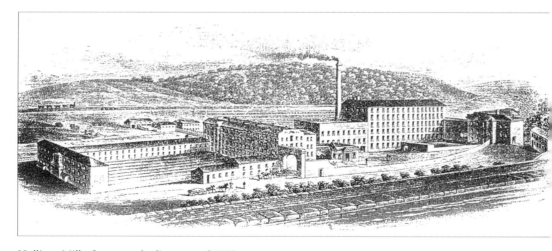

Hollings Mills, from a trade directory of 1895.

TELEGRAMS GREENHOLME SOWERBY BRIDGE
TELEPHONE: HALIFAX 81718

HOLME MILLS
MEMO FROM
Sowerby Bridge, YORKSHIRE.

JAMES GREENWOOD & SON, (SUCCRS.) LIMITED,

WOOLLEN MANUFACTURERS

DIRECTORS:
B. F. CLAY
P. J. CLAY
D. E. CLAY

Above: The letterhead of James Greenwood & Sons, Holme Mills, Hollins Mill Lane. The firm was established in 1861 and was a woollen manufacturer producing blankets and velours.

Right: The mill chimney, Holme Mill, Hollins Mill Lane, 1957. When James Clay & Sons took over Holme Mills they inherited the leaning chimney but there was no danger of it falling – like its more famous rival in Pisa, it had been like that for many years. Holme Mill was formerly the property of James Greenwood & Sons (successors) but production stopped in August 1956 owing to the uncertainty of trading conditions.

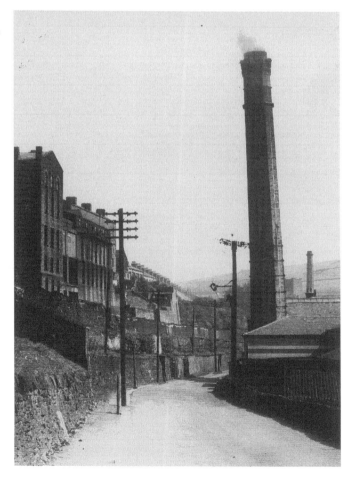

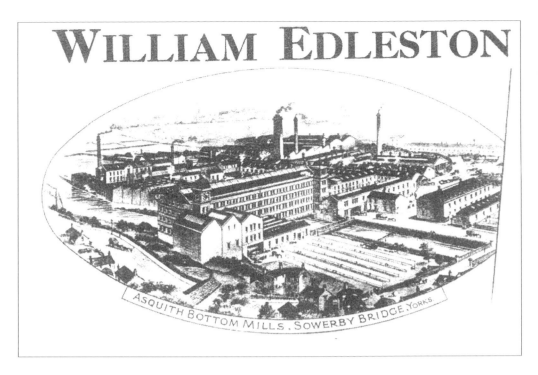

WILLIAM EDLESTON

ASQUITH BOTTOM MILLS, SOWERBY BRIDGE, YORKS

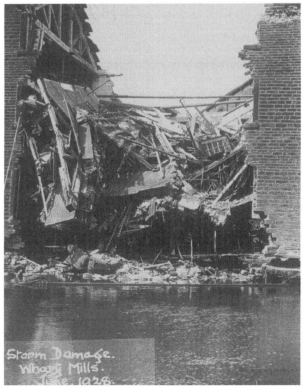

Storm Damage.
Wharf Mills.
June 1928.

Above: Letterhead for William Edleston Ltd, Asquith Bottom Mills, Sowerby Bridge. The firm, established in 1848, produced cashmere, camel hair and mohair coatings.

Left: Storm damage at Wharf Mills, June 1928. A cloudburst sent water rushing down Bolton Brow round the corner by Wharf Garage and into the mill. It brought the whole side of the mill down. The girls in the winding and warping departments escaped without injury but lost all their coats and bags. Clay and Horsfalls, worsted spinners, were founded in 1883.

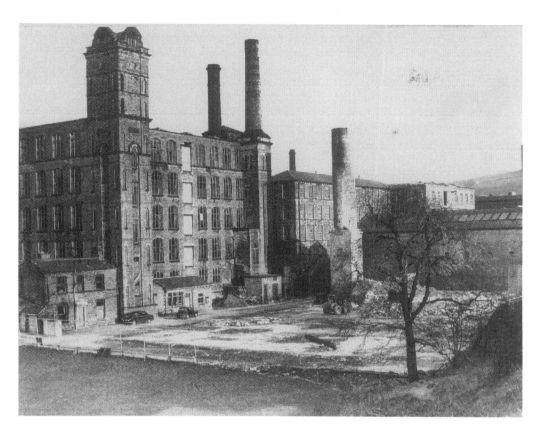

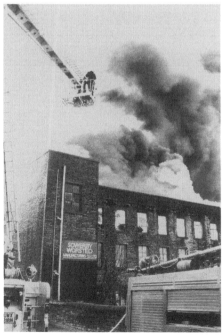

Above: Perseverance and Prospect Mills, Walton Street, 1958, when it was part of Homfray Carpets. Perseverance mill was used as a detention barracks during the Second World War to house prisoners from our own armed forces. The cricket pitch at the bottom of the picture was tarmacked over to make way for a parade ground, and an assault training course was laid out nearby. The detention barracks housed up to 750 prisoners and it is estimated that in seven years, 34,000 men passed through the 'glasshouse'. The mill was originally operated by Shepherd & Blackburn Ltd, cotton spinners and doublers.

Right: Canal Mills of Wakefield Road was a huge complex originally owned by the Edwards family of Pye Nest House. The mills were almost completely destroyed by fire in 1980, during which time Wakefield Road was closed to traffic for several days. At the time of the fire, part of the premises were being used by the Sowerby Worsted company who subsequently moved to an eighteenth-century warehouse building at the bottom of Walker Lane. This grade two-listed building has also recently been destroyed by fire.

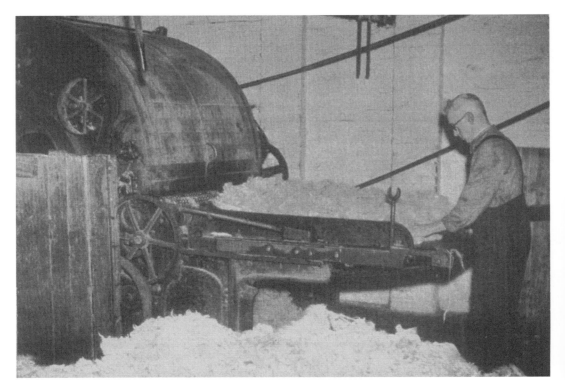

These four photographs show the main stages in woollen production: Duling.

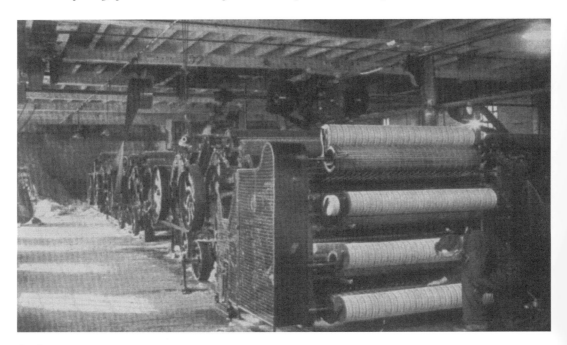

Carding.

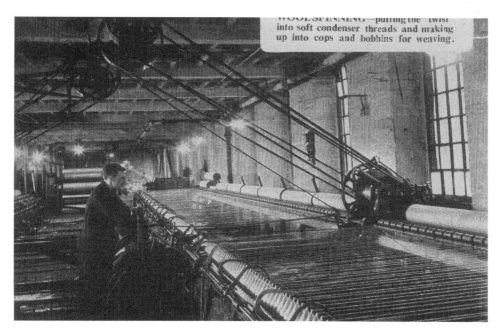

WOOL SPINNING—putting the twist into soft condenser threads and making up into cops and bobbins for weaving.

Spinning.

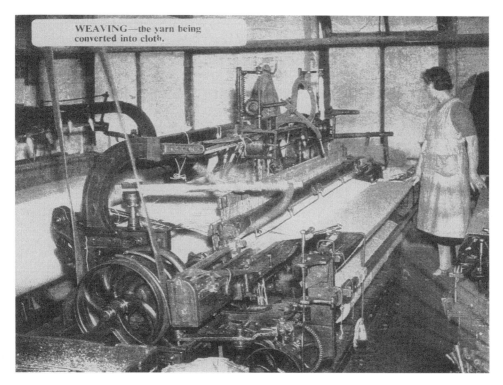

WEAVING—the yarn being converted into cloth.

Weaving. These photographs were taken at Sykes & Company Ltd, woollen manufacturers, of Canal Mills, Wakefield Road.

To be Sold

(With immediate Possession, if required)

By Private Contract,

THE EXTENSIVE

Woollen and Worsted

MILLS,

Situate on the powerful River Calder, at

Sowerby-Bridge, near Halifax,

With the Drying-Houses, Dye-Houses, Warehouses, Counting-House, and all other Conveniences, now occupied by Messrs. W. & G. Greenup, the Owners.

The several Buildings are Three, Four, and Five Stories high; and annexed to them are TWO WATER WHEELS. One Wood and One Iron, each 15 Feet in Diameter, by 5 Feet 7 Inches wide; and another Wooden Wheel, 10 Feet in Diameter, by 6 Feet wide. The entire Bed of the Calder belongs to these Mills, and they are supplied with the whole of the Water therefrom, with a fall of 8 Feet 6 Inches; also with a Culvert to bring the whole of the Water from the Ripponden Brook into the Mill Dam. This Property is capable of being divided into two or three separate Concerns.

ALSO,

A SPACIOUS

Dwellinghouse

Adjoining, with Stable, Carriage-House, and Brew-House, and every Convenience necessary for a genteel Family; and

SIX COTTAGES

Fronting the Rochdale Road.

The Situation of the Premises is peculiarly eligible, being on the Rochdale and Halifax Turnpike Road, and within 80 Yards of the Rochdale Canal, and 2¼ Miles from Halifax; and are Copyhold of Inheritance on a fine certain.

The Owners of this Property have also on Sale Twelve Worsted Throstles of 84 Spindles each, and Two of 108 Spindles each; with complete Preparation Machinery; also, One Doubling and Twisting Frame of 104 Spindles, Warping Mills, and every other Requisite for Worsted Spinning; and Fifty Pairs of Broad Cloth Looms; several Iron and Wooden Screw Presses, with Iron Plates, and Papers with Cloth; Bale Presses; Broad and Narrow Out-door and Drying-House Tenters and other Utensils.

Apply to the Owners, on the Premises.

Advertisement: 'To be Sold: the Extensive Woollen and Worsted Mills Situated on the Powerful River Calder at Sowerby-Bridge near Halifax'.

Trade
and Industry

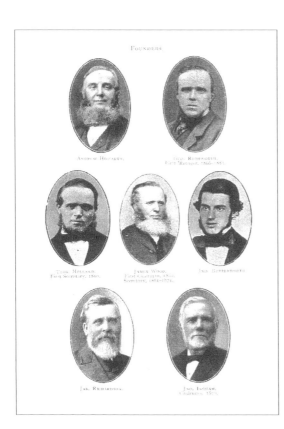

FOUNDERS

Andrew Hogarth.

Geo. Rushworth,
First Manager, 1866-1881.

Thos. Holland,
First Secretary, 1860.

James Wood,
First Chairman, 1866,
Secretary, 1860-1874.

Jno. Butterworth.

Jas. Richardson.

Jno. Ingham,
Chairman, 1908.

Left: The founders of Sowerby Bridge Industrial Society (the Co-op). On 3 March 1860, a crowded public meeting was held at the town hall and a motion to form the society was passed unanimously. Progress was fast: land in West Street was purchased and premises built. The grocery department opened on 13 December that year even though the plate glass for the windows had still not arrived. The society suddenly went into voluntary liquidation in 1968.

Below: Sowerby Bridge Industrial Society Ltd, van and group. Why are they wearing those hats?

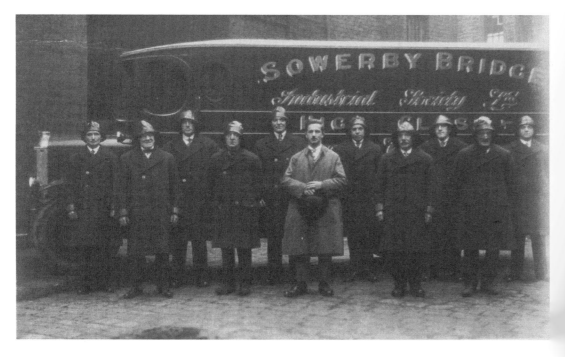

Right: The Co-op's new premises in West Street, built in 1904 at a cost of £5,500. The new premises were of 'the most up-to-date construction - a spacious and lofty butcher's shop, with cellarage and back premises fitted up with the latest appliances, including tripe-boiling and preparing, the whole lined with white glazed bricks; a large front confectionery shop, with tea-room; a spacious bakery, with two large ovens and all the needful machines and appliances; splendid front showrooms over for the furnishing department and a well fitted-up joiners and cabinetmakers shop at the rear'. By 1885 the society had branches at Ripponden, Mill Bank, Warley, Sowerby, Bolton Brow, Triangle, West Vale and Tuel Lane, followed by Albert Road (1894) and Norland (1895).

Below: Frank Normanton, hairdresser and tobacconist, standing in the doorway of his shop under the railway viaduct at the end of Walton Street, *c.* 1930. The sign shows that it was also one of the parcel offices for Halifax Corporation Tramways. The shop was later a pet shop.

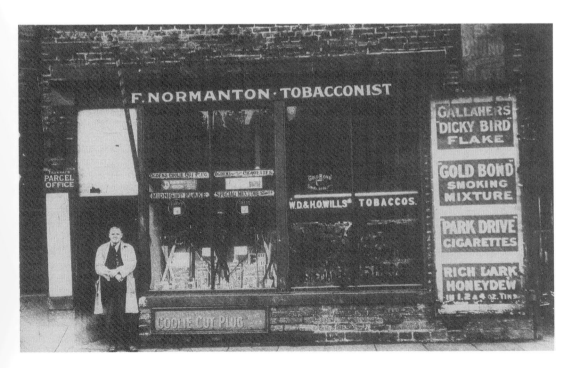

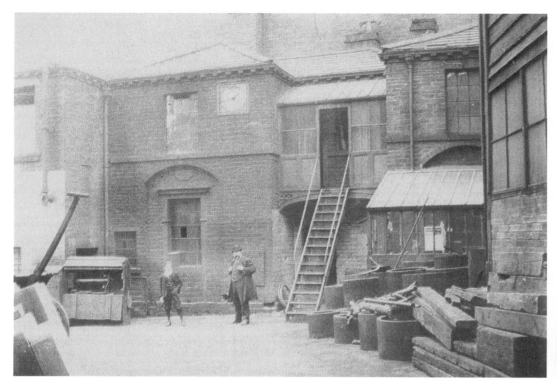

The yard at Pollit & Wigzells. In the age of steam, Sowerby Bridge was known throughout Britain and many parts of the world for quality and craftsmanship. Pollit & Wigzells could trace its history back to 1786 when the company was founded by Thomas Bates. The firm had a good reputation as makers of large engines of unusually high speed coupled with fuel economy. At their peak, there were over 400 men employed at the works and over 1,000 engines were produced, each one being given a female name. By 1930, the age of steam was over and the company went into voluntary liquidation. Wood Brothers of Valley Iron Works were another local firm producing steam engines until they closed down in 1924.

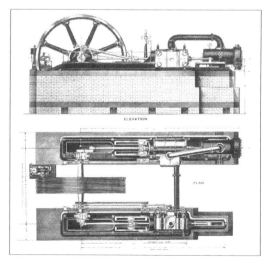

The improved Horizontal Cross Compound (side by side) Condensing steam engine, manufactured by Pollit & Wigzell, engineers and millwrights, of Sowerby Bridge, telephone: Sowerby Bridge 155 (two lines). This is an illustration from their catalogue. The engine was fitted with a Pollit and Wigzell patent horizontal single-acting Air Pump, specially adapted for high piston speeds.

At the gasworks. There had been a Sowerby Bridge gas company, a private concern, from 1834 but there were many complaints of the supply being unsatisfactory. Wharf Street was first lit by gas in 1854. Willow Hall mill was the first mill to use gas for lighting but the supply was so poor that when the mill lights were turned on all the lights on the street went out. The company was taken over by the council in 1861 for the sum of £18,000. Sowerby Bridge continued to make its own gas until 1954.

An advertisement for Francis Berry, ironfounder.

Whiteley Varley's shop, West Street, 1910, decked out for the coronation of King George V. Many locals will remember that Varley's greengrocery business later moved into a wooden building at The Nook next to Nook Fisheries, which was located where the yard of EPS tool hire now stands.

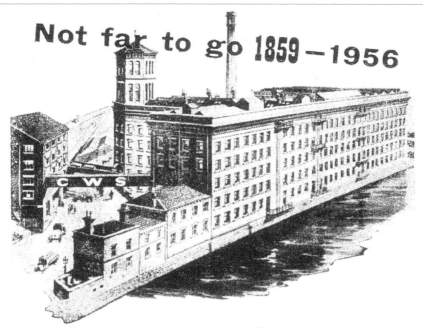

Not far to go 1859 – 1956

THE management and staff of the
C.W.S Union Flour Mills are proud
to greet the occasion of the Sowerby Bridge Centenary Celebrations.

To our Fellow Townsmen and Women, Union Mill, one of the
largest inland mills in the country, has been a recognised landmark
for generations. No less are its products recognised wherever they
are used, for their unsurpassed quality and purity. First built in
1859, Union Mill has not far to go to qualify for a century of
service to the community.

In the future, as over the past ninety-seven years, all who use
C.W.S Union Mill products are assured of the finest quality,
competitive prices, and prompt delivery.

C.W.S Flour is milled from the best-quality imported and Native
Wheats available.

*Animal feeding stuffs include
finest-quality cattle, poultry
and pig foods.*

*Flour is pre-packed
in 3 lb. and 6lb.
packets.*

C.W.S UNION MILLS

*SOWERBY BRIDGE,
YORKS.*

**The Co-operative Wholesale Society Limited
1 Balloon Street - Manchester 4**

Advertisement for the Co-operative Wholesale society flour mills, Union Mills, Walton Street,
taken from a booklet entitled 'An Exhibition of Local Industries, 24–27 October 1956'. Established
in 1859, at this point there were only three years to go until the society's centenary. The mills
burned down in 1965. The booklet lists sixty-five firms operating in Sowerby Bridge at that time,
covering over forty different industries.

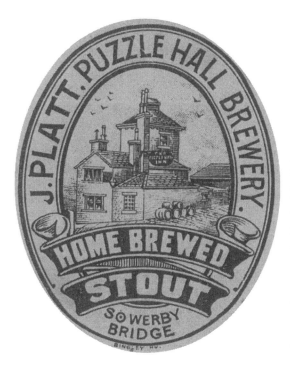

Left: A beer label for Home Brewed Stout, produced at the Puzzle Hall Inn and Brewery, Hollins Mill Lane. The beer was brewed in the tower at the rear. The pub was bought out by Wards of Sheffield in 1935 and brewing ceased on site.

Below: An advertisement taken from *The Sowerby Bridge Chronicle* of 1890. The Bank Brewery offices were in Tuel Lane (now Tower Hill). The *Chronicle* was produced in their office in the yard behind the town hall (now Lloyd's Bank).

BANK BREWERY COMPANY,
SOWERBY BRIDGE.

LIST OF PRICES.
Brewed from the Best Malt and Hops.

Mild Ale -/10 per gallon.
Light Bitter Beer (Red Star Brand 1/- per gallon.
XXX Ale..................... 1/2 per gallon.
Bitter Beer 1/4 per gallon.
Strong Ale (Old Tom) 1/6 per gallon.
" Extra " Stout 1/2 per gallon.
" Magic " Stout 1/6 per gallon.

Private Families supplied with Small Casks of Beer and Stout.

" MAGIC STOUT," in Bottle, 2s. per Doz.

" MAGIC STOUT " is the most marvellous strength-
ening drink in the world; combines all the
digestive properties contained in Barley,
Malt and Hop Flower.

Sold Retail
BY ALL LICENSED DEALERS.

Church,
Chapel and
Schools

Painted in 1800 by the Halifax artist John Horner (1784–1867) this is the Old Brig chapel which was built around 1526 and which stood at the Warley end of old Sowerby Bridge (now County Bridge). Why this location was chosen is a mystery as the chapel was very close to the river and was susceptible to flooding when the waters rose. The scene must have been very similar on the 4 January 1644 when the Battle of Sowerby Bridge was fought. A force of Roundheads commanded by major Eden marched from Heptonstall via Sowerby and attacked the Royalist forces guarding the bridge. The Royalists were defeated with three killed and Captain Clapham and forty-one soldiers taken prisoner.

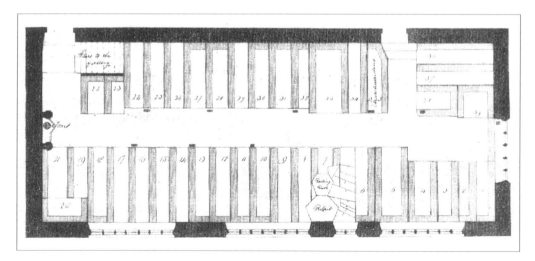

Plan of the Old Brig chapel made by John Oates in 1819 shortly before the chapel was demolished. This is the ground floor with pulpit, reading desk, font and churchwarden's pew all marked, as are steps leading up to the gallery.

An advertisement for the materials of the Old Brig chapel to be sold by auction on 1 June 1821. F.W. Cronhelm wrote thus of the chapel: 'There is a spot in Calderdale, beneath the Norland Wood, Where years ago, by an ancient tree, a lowly chapel stood, It is a green and sheltered nook just where the rivers meet, The Calder and the Ribourne stream, by lofty Werla's feet.'

SOWERBY-BRIDGE
Old Chapel.

To be SOLD by AUCTION,
BY MR. TOWNSEND,
UPON THE PREMISES, IN LOTS,

On Friday, the 1st Day of June, 1821, at 2 o'Clock in the Afternoon,

THE WHOLE OF

The Materials

Of the said CHAPEL;

Consisting of the Slate, Roof, Windows, Galleries, Pews, Floors, Walls, &c.

Any Person may view the same upon Application to

Mr. JAMES JACSON, of Sowerby-Street, the Clerk.

Printed by J. WALKER, 43. Silver Street, Halifax.

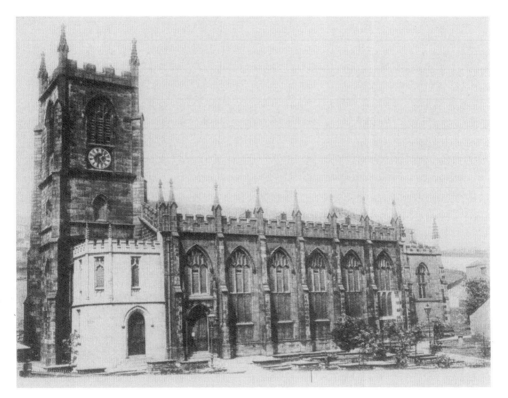

Christ Church, Wharf Street, which was built, to replace the Old Brig chapel in 1819, by John Oates of Salterhebble on land bought from James Goodhall and Timothy Bates. The foundation stone was laid on 22 April 1819 and the church opened on 24 May 1821. The total cost was £6,812 3s 9d. There is a gravestone in the graveyard with the inscription: 'James Whitaker of Causeway Head, Warley, who departed this life May 16 1821, in the sixty-eighth year of his age, whose remains were the first interred in this ground'. The church was badly damaged by fire in 1894 when fireman Jonathon Coulson was killed. The new vestry, added in 1895, shows up bright and clean against the rest of the smoke-blackened building.

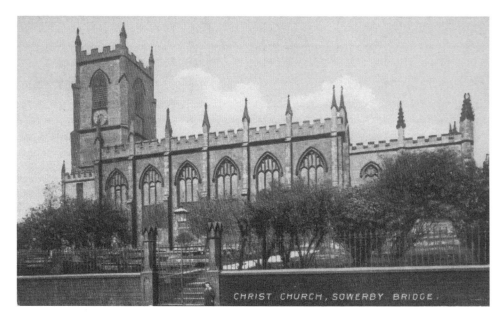

Another view of the church from Wharf Street. There is a communion table in the church bearing the date 1526, the building date of the Old Brig chapel. The clock dates to 1839.

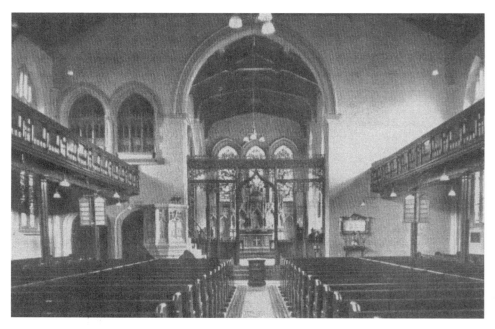

Interior of Christ Church. The Chancel Screen was added in 1935 and was given by Percy Carter of Willow Lodge in memory of his parents who were regular worshippers at the church. The war memorial placed in the church in 1921 records the names of sixty-four men connected with the church who died in the First World War.

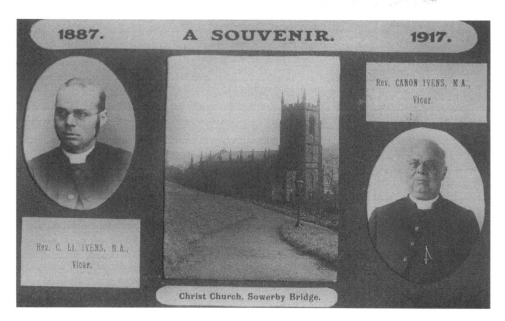

Postcard of 1917 issued to commemorate the fact that the Vicar of Sowerby Bridge, the Revd Canon Ivens MA, had been the incumbent for thirty years. Also of interest is the view of Christ Church, showing how pleasant Church Bank was before development of the area took place.

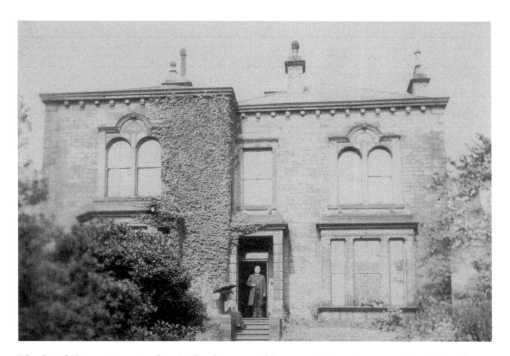

The Revd Canon Ivens standing in the doorway of Sowerby Bridge vicarage on Beech Road. When the new vicarage was built on Park Road, the old building was sold and later became the Woodnook Inn. At the time of writing the building has just been demolished.

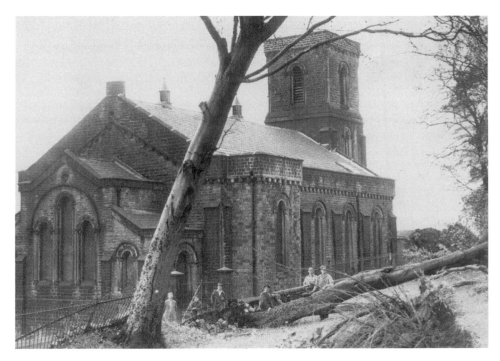

Trees blown down by strong winds near St George's church, at the junction of Quarry Hill and Haugh End Lane, 15 October 1962. St George's was designed by Edward Walsh in the Norman style and opened in 1840. It was founded by the influence of the Rawson family on land given by Robert Stansfeld. The stone was donated by Mr Priestley of White Windows. The church closed on 1 December 1989 and has now been converted into flats.

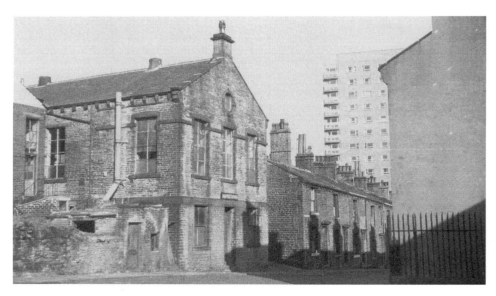

This is a picture of the now-demolished Baptist church, Industrial Road, May 1967. In the background can be seen the high-rise block of flats, Ladstone Towers, built in 1965.

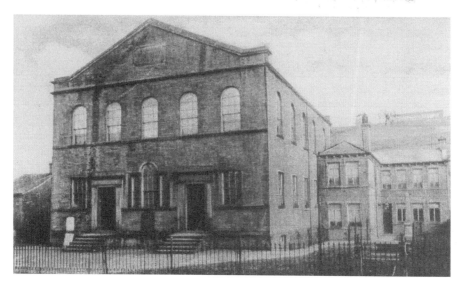

West End Congregational church. The site for the church was secured in 1838 from Mr William Edleston who made a £100 contribution towards the building of the church. The foundation stone was laid 19 June 1839 and the church opened for public worship on 10 June 1840 at an entire cost of £2,500. The church was closed in 1957, two tenants at that time being Sowerby Bridge YMCA and Sowerby Bridge Golden Age club. The church was later demolished and a petrol station built on the site, although this has also recently been demolished.

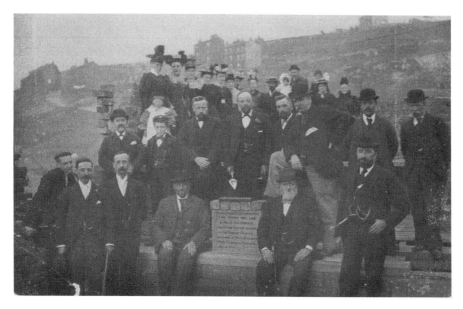

Laying the foundation stone for the Sunday School at the West End Congregational church. The inscription on the stone reads: 'This stone was laid by Mr T. Chadwick, one of the Superintendents of the Sunday School on behalf of Past and Present Male Teachers and Scholars, July 10 1897'. In 1898 the Sunday School had thirty teachers and 407 scholars.

SOWERBY
Sunday School.

On *WHIT-SUNDAY*, *May 18th, 1823,*
TWO
SERMONS
WILL BE PREACHED AT
Sowerby Church,
By the Rev. S. KNIGHT, A.M.
VICAR OF HALIFAX,
And a COLLECTION made after each Service, in Behalf of the above Institution.

☞ Service to commence at THREE o'Clock in the Afternoon, and at SIX in the Evening.

Printed by T. WALKER, 43, Silver-Street, Halifax

Poster advertising two sermons at Sowerby Sunday School, 1823.

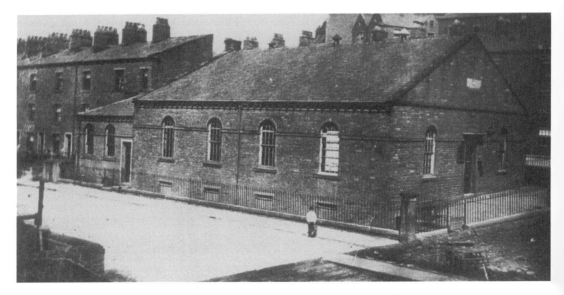

Old Tuel Lane Methodist chapel, which opened in 1854 but which was demolished only nineteen years later to be replaced by the United Methodist Free Church to accommodate the growing congregation. The 1873 church was destroyed by fire in 1988, to be replaced by the present St Paul's.

Above: A view of Bolton Brow Methodist church, taken in 1974. The first chapel, built in 1806, stood further up Bolton Brow and was demolished in 1958. The present building replaced it in 1831 and was extended in 1868. It stands on a steep slope and has six floors at the rear, with the bottom four providing warehousing for the canal wharf. The chapel was famous for its water-powered organ of 1897 which was electrified when it was later moved to Christ Church. The chapel closed in 1979.

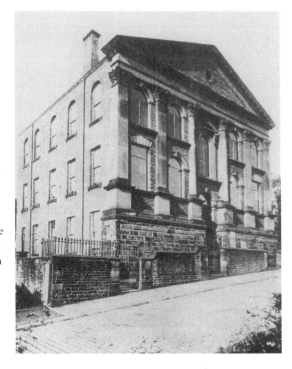

Right: The Primitive Methodist chapel, Sowerby New Road, 1905. In 1821 a Primitive Methodist Society was formed at Norland and this moved to the house of Mr John Robinson in Sowerby Street in 1826, with the first chapel being built nearby in 1839. The chapel in the photograph was opened on 14 April 1870 and cost £3,000. It closed in 1958 and was subsequently demolished. The telephone exchange now stands on the site.

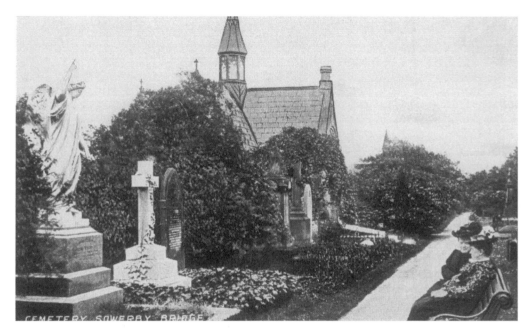

Sowerby Bridge Cemetery, off Sowerby New Road. The cemetery was opened in 1861 and there were originally two chapels, each of which cost £500 to build. The one nearest the camera was for non-conformist services and the one furthest away behind the tree was for Anglican services. The Anglican chapel has since been demolished. The total cost of the cemetery was £5,700.

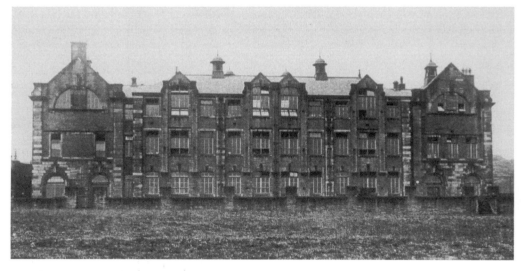

Sowerby Bridge Secondary School, Albert Road, opened on 7 May 1910 by Bishop Welldon, Dean of Manchester, and designed to accommodate 120 girls and eighty boys. The architects were Longbottom and Culpan of Halifax and the total building cost was £14,000. The first chairman of the governors was Mr E.E. Pollit of the firm Pollit & Wigzell. The school later became Sowerby Bridge Grammar School but in more recent times has become Sowerby Bridge High School. The old building shown in the photograph has recently been demolished to make way for a new school.

twelve

Transport

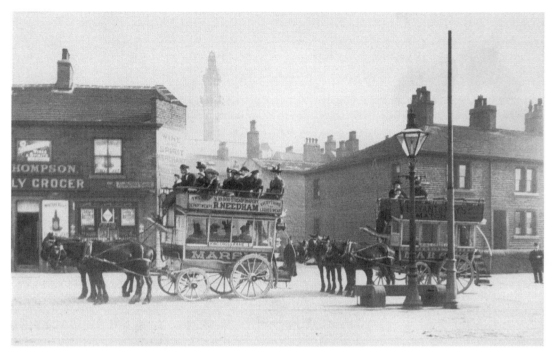

Although taken at King Cross, this photograph has special relevance for Sowerby Bridge as John Marsh started his transport company from the Royal Hotel, Sowerby Bridge, *c.* 1870. The first horse-drawn service ran between Sowerby Bridge and Halifax and was later extended to Rishworth. The main stables were at Hall Street, Halifax. The horse-drawn buses had ceased running by 1900, and John Marsh operated the first motorised taxis in Halifax.

NOTICE.—EXTRA 'BUS SERVICE.

On and after Monday, August 1st, 1898,

John Marsh & Co., will run their Saloon Omnibuses

Between the Office, Commercial Street, Halifax, Sowerby Bridge and Rishworth, as under.

HALIFAX (Commercial Street) TO SOWERBY BRIDGE AND RISHWORTH.

																			SATS. ONLY.		SUNDAYS.			
Halifaxdep.	6 15		10 0	10 45	11 30	12 30	1 45	2 15	3 10	3 50	4 40	5 30	6 40	7 30	8 15	9 0	9 30	2 15	2 30	7 0	8 0			
King Cross	6 30		10 15	11 0	11 45	12 45	2 0	2 30	3 25	4 5	4 55	5 45	6 55	7 45	8 30	9 15	9 45	2 30	2 45	7 15	8 15			
Willow Hall Lane ...	6 35		10 20	11 5	11 50	12 50	2 5	2 35	3 30	4 10	5 0	5 50	7 0	7 50	8 35	9 20	9 50	2 35	2 50	7 20	8 20			
Sowerby Bridge, arr.	6 40			11 15	12 0	1 0		2 45		4 20	5 10	6 0	7 10	8 0	8 45	9 35	10 5			7 30	8 30			
(Royal Hotel) dep.	6 45	9 20	10 30		12 30		2 15	3 40		5 35		7 15						2 45	3 0					
Triangle	7 0	9 35	10 45		12 45		2 30	3 55		5 50		7 30						3 0	3 15					
Ripponden	7 10	9 50	11 0		1 0		2 45	4 10		6 5		7 45						3 15	3 30					
Rishworth ... arr.	7 20						2 55	4 20		6 15								3 30						

RISHWORTH AND SOWERBY BRIDGE TO (Commercial Street) HALIFAX.

														SATS. ONLY.		SUNDAYS.					
Rishworth .. dep.	7 20						3 0		4 30		6 45								6 30		
Ripponden	7 25	10 0		11 30		1 30	3 10		4 40		7 0		8 0				5 0	6 45			
Triangle	7 35	10 10		11 45		1 45	3 25		4 50		7 10		8 10				5 10	7 0			
Sowerby Bridge, arr.	7 45			12 0					5 5				8 25								
(Royal Hotel) dep.	9 5	10 25	11 30	12 30	1 15	2 5	2 45	3 40	4 30	5 35	6 30	7 25	8 15	8 40	9 45	1 30	5 25	7 15	7 45		
Willow Hall Lane ..	9 20	10 40	11 45	12 45	1 30	2 20	3 0	3 55	4 45	5 50	6 45	7 40	8 30	8 55	10 0	1 45	5 40	7 30	8 0		
King Cross	9 30	10 50	11 55	12 55	1 40	2 30	3 10	4 5	4 55	6 0	6 55	7 50	8 40	9 5	10 10	1 55	5 50	7 40	8 10		
Halifax .. arr.	9 40	11 0	12 5	1 5	1 50	2 40	3 20	4 15	5 5	6 10	7 5	8 0	8 50	9 15	10 20	2 5	6 0	7 50	8 20		

FARES—Halifax to Sowerby Bridge, 3d., In or Out. Sowerby Bridge to Halifax, 4d., In or Out.
Opened and Closed Hearses, Mourning Coaches, and Private Carriages for Funerals. Elegant Wedding Equipages. Landaus and Broughams for Private Parties. Char-a-bancs and Waggonettes. Hansoms, Cabs, &c. Horses Let by the Week or Month Cabs, Day or Night. All Orders promptly attended to. Parcels left at the Office, Commercial Street, will be promptly attended to.
Telephone Nos.—Halifax 55. Sowerby Bridge 9. OFFICES:—14, COMMERCIAL STREET, HALIFAX.

Timetable for Marsh's horse-drawn omnibuses, 1898.

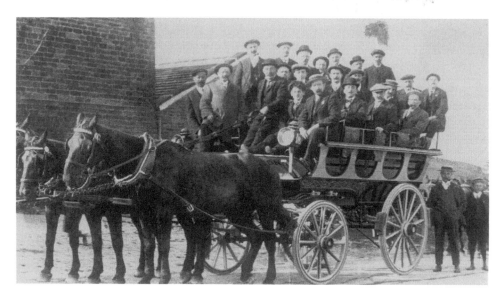

The information with this photograph states that: *Rushworth owned five waggonettes which he hired out with or without the horses. He was the landlord of the Town Hall Tavern* [recently demolished] *on Corporation Street, Sowerby Bridge, and also owner of the foundry of his name. There was a sixteen-seater, a ten-seater and a seven-seater. Tommy Smith's father is the driver in this picture. He worked for the Sowerby Bridge Victoria Livery station. The passenger on the extreme right was Hipwood, one-time groom at Field House. JSR always hired one of the Rushworth's wagonettes on the 12 August (ACR's birthday) and took all and sundry on to the moors for a picnic. Note the three horses abreast. Tommy Smith was JSR's horseman and then FPSR's. JSR was John Rawson of Haugh End, ACR being his wife. Hipwood was the father of Charlie Hipwood who ran a taxi business in Sowerby Bridge after the last war. John H.S. Rawson 1957.*

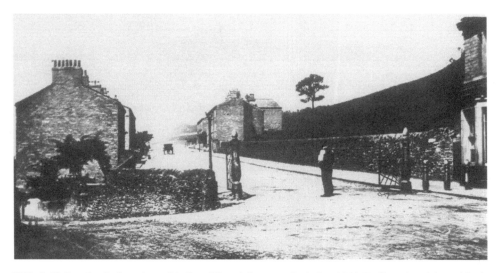

Wakefield Road at its junction with Canal Road down to the left, *c.* 1868. Traffic using this road had to stop at the toll gate and pay the required toll. The toll gates were taken down in 1870 and the toll house on the right was demolished many years ago. This is the 1824 Sowerby Bridge to Salterhebble turnpike. The main road through the town centre was the 1735 Halifax to Rochdale turnpike.

Poster advertising the Blackstone Edge tolls for let, including the ones at Sowerby Bridge, May 1833.
The rent for the Sowerby Bridge Bar was £390 which the tenant recovered by collecting the tolls.

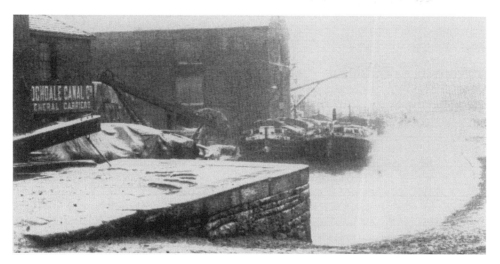

Below No. 1 Lock, Sowerby Bridge canal basin, *c.* 1907. Two canals meet at Sowerby Bridge, the Calder and Hebble Navigation which opened in 1770, and the Rochdale Canal completed in 1804. Unfortunately the two canals were built to different specifications so the same barge could not use both. Goods had to be unloaded from one barge and reloaded on to another to continue the journey through Sowerby Bridge. This was carried out in the large warehouse (the Salt Warehouse) in the centre of the photograph. This made Sowerby Bridge an important centre in the canal network.

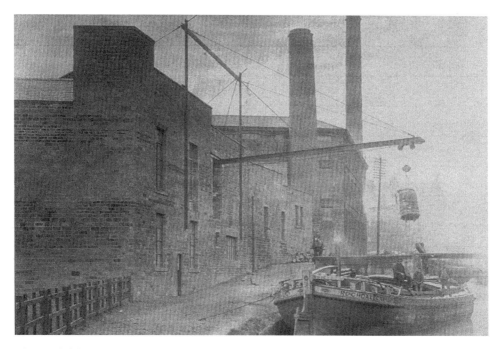

The Rochdale Canal Company's barge *Primrose* reached Sowerby Bridge in June 1921 and is shown here unloading the final bale of its cargo of wool into Lock Hill Mill. Lock Hill Mill has now been demolished (1995). The last loaded barge to use the Calder and Hebble Navigation was *Frugality* in 1955, after that the canals fell into disuse.

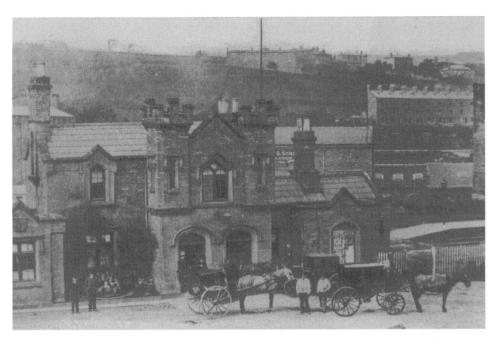

The first railway station in Sowerby Bridge, built *c.* 1840 for the Lancashire and Yorkshire Railway Company and located near the engine sheds off Sowerby Street. This photograph was taken in around 1872, four years before this station was closed, and the new one opened at the end of Station Road. This first station was found to be too far from the town centre and was too small. The site was also required to extend the goods traffic sidings. Three cabs await the arrival of the next train.

MANCHESTER AND LEEDS RAILWAY.

THE Public are respectfully informed, that on and after MONDAY, the 5th October, 1840, this Line will be FURTHER OPENED, for the Conveyance of Passengers and General Merchandise, between LEEDS and HEBDEN BRIDGE; and the Trains will start from each of those places, and depart from the intermediate Stations, as follows:—

Start from Hebden-Bridge.	Depart from Sowerby Bridge	Depart from Brighouse.	Depart from Dewsbury.	Depart from Horbury.	Depart from Wakefield.	Depart from Normanton.	Arrive at Leeds.
MORNING.	M. H.	M. H.	M. H.	M. H.	M. H.	M. H.	M. H.
8 o'clock.	15 past 8	33 past 8	52 past 8	9 o'clock.	12 past 9	21 past 9	50 past 9
30 minutes past 11	45 do. 11	2 do. 12	21 do. 12	30 past 12	42 do. 12	50 do. 12	20 do. 1
AFTERNOON.							
15 minutes past 3.	30 do. 3	48 do. 3	7 do. 4	15 do. 4	27 do. 4	25 do. 4	6 do. 5

Start from Leeds.	Depart from Normanton.	Depart from Wakefield.	Depart from Horbury.	Depart from Dewsbury.	Depart from Brighouse.	Depart from Sowerby Bridge	Arrive at Hebden Bridge.
MORNING.	M. H.	M. H.	M. H.	M. H.	M. H.	M. H.	M. H.
45 minutes past 7.	15 past 8	22 past 8	34 past 8	43 past 8	3 past 9	21 past 9	36 past 9
10 o'clock.	30 do. 10	38 do. 10	49 do. 10	11 o'clock.	18 do. 11	36 do. 11	50 do. 11
AFTERNOON.							
3 o'clock.	30 do. 3	38 do. 3	49 do. 3	4 do.	18 do. 4	38 do. 4	50 do. 4

Timetable for trains to and from Sowerby Bridge, October 1840. Also of interest is the illustration of the engine and carriages, with men sitting on the carriage roofs as if they were the drivers. From *The Halifax Guardian,* 10 October 1840.

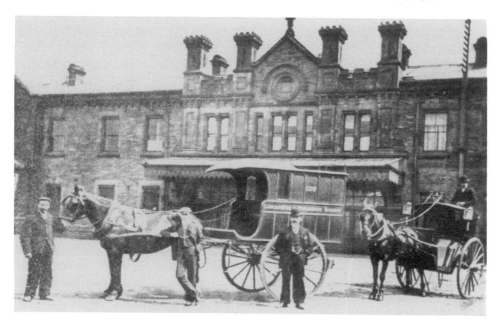

Sowerby Bridge railway station, built in 1876 to replace the original one. The vehicle in the centre of the picture is a delivery van for the Lancashire and Yorkshire Railway Company, and behind it is a hansom cab of the Victoria Livery Company of Sowerby Bridge. A new footbridge was built over the river Calder to connect the new station to the town centre. The station was badly damaged by fire in 1978 and was rather hastily demolished by British Rail, who, allegedly, had heard that the station might become a listed building.

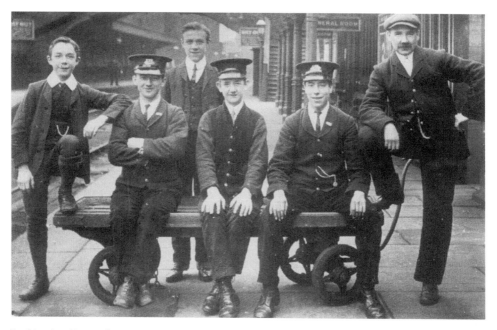

Luddenden Foot railway station staff *c.* 1904. The station closed on 10 September 1962.

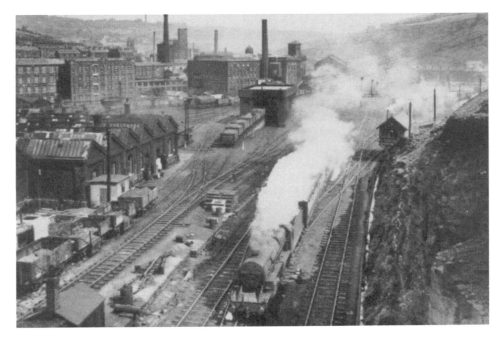

Sowerby Bridge goods yard seen from over the tunnel entrance, *c.* 1952. The train below is heading for Hebden Bridge and Todmorden. Behind the water tower can be seen the CWS flour mills which had their own railway siding for delivering grain and shipping out the flour. The engine sheds are on the left.

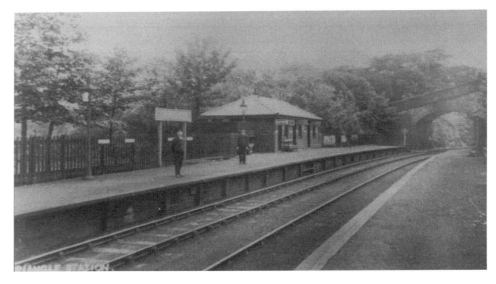

Triangle railway station. The Rishworth branch line opened for the carriage of goods traffic on 15 July 1878 and for passengers on 5 August 1878, the fare from Ripponden to Sowerby Bridge and vice versa being three pence. That first run with passengers covered the three miles from Sowerby Bridge to Ripponden in seven minutes. The extension to Rishworth was not opened until 1881. Competition from buses led to the end of regular passenger services in 1929, and to goods traffic in 1958.

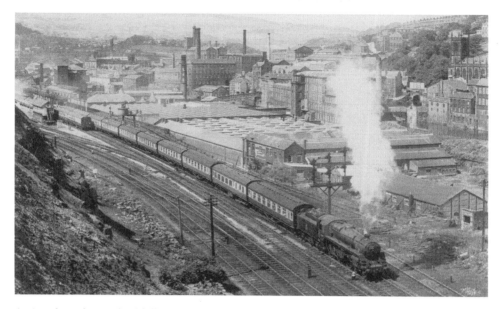

A view from the Norland hillside of a steam train leaving Sowerby Bridge en route for Halifax. This photograph was taken in 1959 by the late Venerable Eric Treacy, Archdeacon and Vicar of Halifax, who was a railway enthusiast. In the centre of the photograph can be seen the sheds of Lee's spinning and doubling mill. To the right of the engine smoke is the long shed containing the rifle range of the Sowerby Bridge Rifle Club. Above Lees is the footbridge connecting the railway station with the town centre.

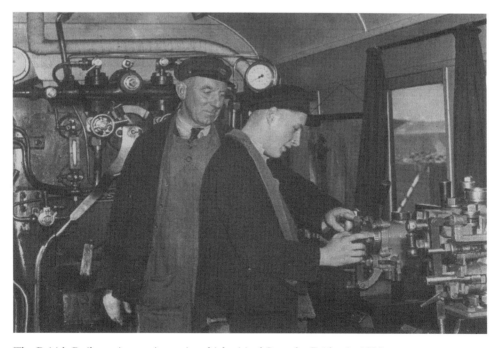

The British Railways instruction train which visited Sowerby Bridge in 1950.

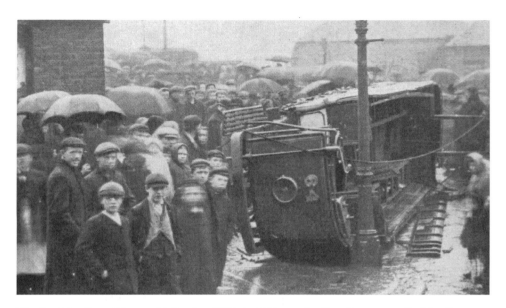

The Pye Nest Tram Disaster, 15 October 1907. At 5.35 a.m. the No. 64 tram was climbing Pye Nest Road travelling towards Halifax with an estimated sixty passengers on board. The electric supply suddenly failed and the tram started to roll backwards. The conductor, Walter Robinson, and the driver, Trevor Simpson, tried to apply the brakes but to no avail. The tram gathered speed and left the tracks and overturned when it reached the bend at the top of Bolton Brow. Conductor Robinson and two passengers were killed and many were badly injured. History was to repeat itself on 6 September 1993 when a runaway lorry crashed at the same spot killing six people.

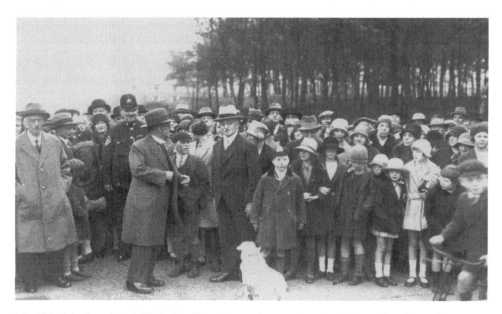

Mrs Fishwick, the wife of Cllr Arthur Fishwick, cut the tape from Providence Place forward up into Sowerby in 1930. This was to officially open Sowerby New Road after it had been widened and straightened. The two men at the front are Cllr Fishwick and Cllr John Bates, chairman of the council.

People
and Events

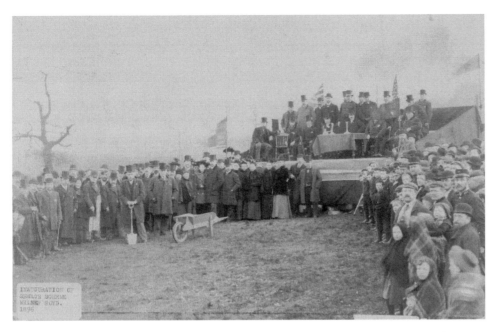

Cutting the first sod at the inauguration of the new sewerage works at Milner Royd, April 1896.

An interesting selection of fancy lace collars at Tuel Lane School in 1898. The photograph was taken by Holdsworth & Wilkinson of Hepworth, Huddersfield.

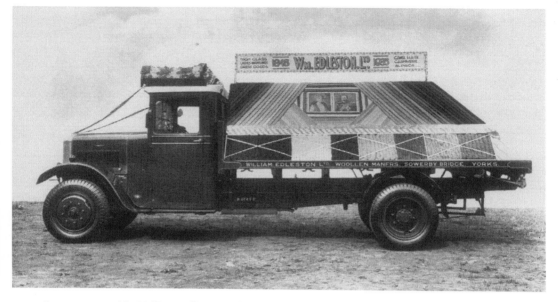

A wagon owned by William Edleston Ltd, woollen manufacturers, 1935, decorated for George V's Silver Jubilee celebrations. The company was established in 1848 and produced high class ladies' mantlings and dress goods. The sign also shows that the company processed camel hair, cashmere and alpaca.

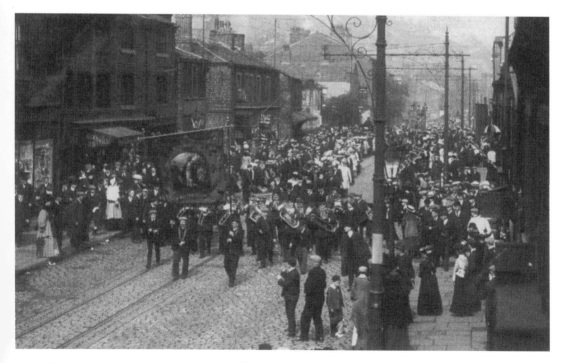

This photograph has a suggested date of 1904. A procession makes its way along Wharf Street towards County Bridge led by a brass band. The religious banner would suggest a church or chapel event. They are passing Gledhill's butchers at No. 25.

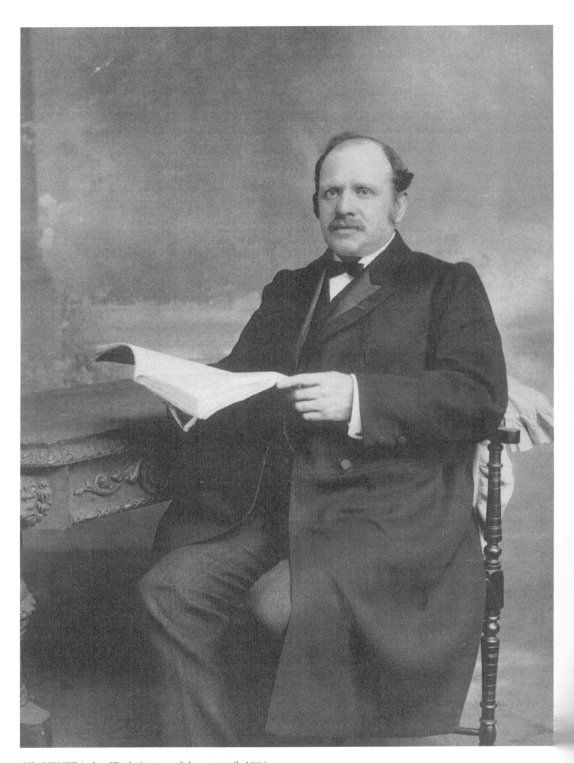

Cllr J.W. Whiteley JP, chairman of the council, 1906.

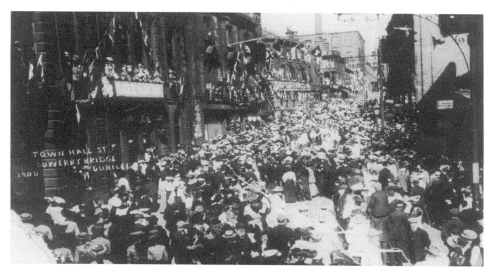

1906, Town Hall Street – the procession can hardly get through for the densely packed spectators. The men pulling the Rushcart are just entering in the bottom right-hand corner, a sight perhaps never to be repeated. The procession started out from Allan park and terminated at Crow Wood park. 1906 was a momentous year for the town as it marked the jubilee celebrations of the urban district council. On Saturday 8 September, in honour of the event, the inhabitants were invited to 'decorate and illuminate their mills, places of business and residencies for the purpose of illumination only; gas is offered free by the council'.

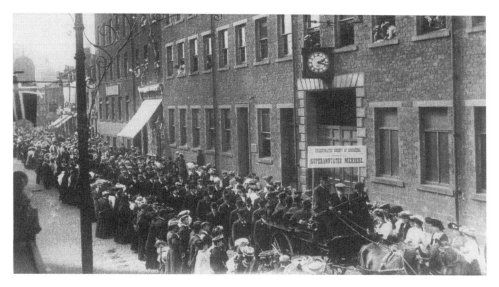

1906, the procession passes Pollit & Wigzells' factory at 2.20 p.m. This part of the procession shows the Amalgamated Society of Engineers (Superannuated Members). No doubt some of them are passing their own workplace. The procession included council officers, retired and present-day police constables, the Fear Not Friendly society, and over a dozen Sunday Schools. The day ended with fireworks and a fire portrait of the chairman of the council, Mr J. W. Whiteley JP, followed by the wish 'Success to our town'.

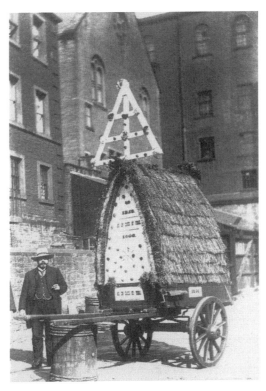

Left: The Rushcart at the Wharf, with Bolton Brow Methodist church and Sunday School behind, 1906. The Rushbearing event was revived that year to take part in the jubilee celebrations. It was permanently revived in 1977 and has been held every year since. It harks back to the time when the rushes on church floors were renewed as winter approached. The procession visits several churches to deliver token bunches of rushes.

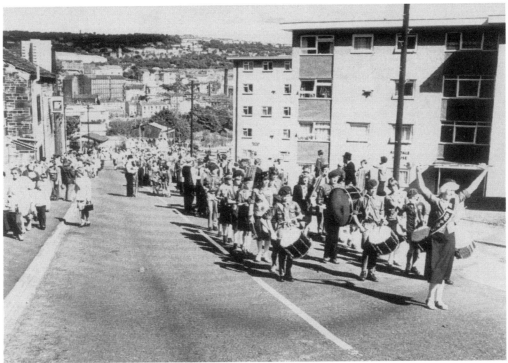

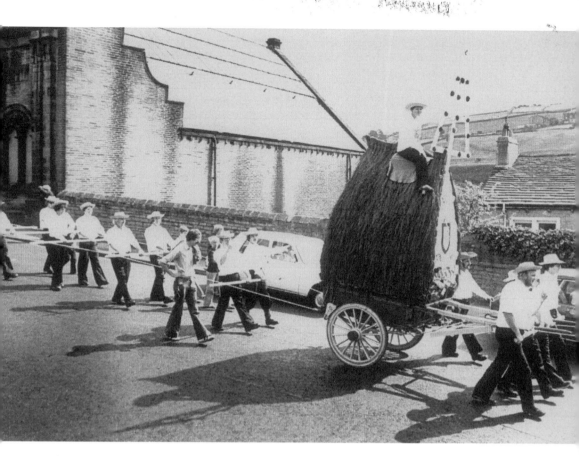

Rushbearing festival, September 1978. Holding back the cart on the steep hills was almost as hard as pulling it up them! Bolton Brow Sunday School is in the background. (Photograph by J. Townsend)

Opposite below: The Rushbearing procession of 1978 starts on the steep climb up Quarry Hill towards St George's church. The Whitbread pub on the left is The Royal Oak. The flats on the right are on the site of a rundown part of the town known locally as Bogden; the area was later purchased and cleared. These flats were built in 1965. The flats in the photograph, Airdale House and Eskdale House, have just been demolished and are being replaced by new housing. (Photograph by J. Townsend)

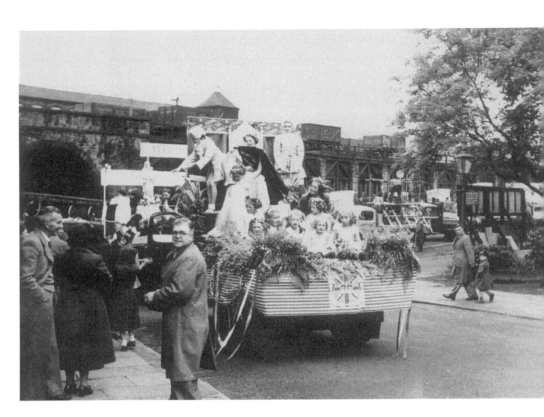

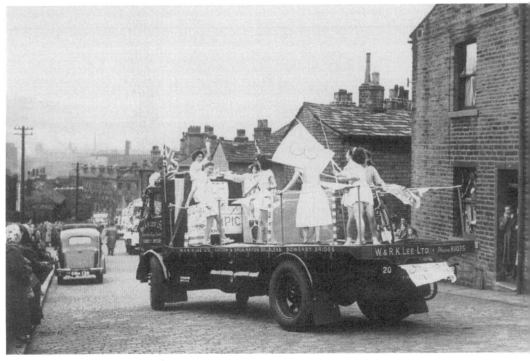

Photograph of councillors and officials taken before the final meeting of Sowerby Bridge Urban District Council, March 1974, and the subsequent merger with other local councils to form Calderdale MBC. Back row, left to right: Cllr Philip Dyson; Mr Bert Barrand (housing manager); Cllr Trevor Asquith; Cllr Raymond Murphy; Cllr Ronnie Milner; Mr William Luty (baths manager); Mr Irvin Feather (engineer and surveyor); Cllr David Sim; Cllr John Broadbent. Middle row: Mr Kevin Morris (acting deputy clerk); Mr Frank Uttley (chief financial officer); Mr John Swift (acting parks superintendent); Mrs Susan Newbould (acting chief librarian); Mrs Sylvia Luty (baths matron); Cllr Doreen Wood; Cllr Elizabeth Buick; Cllr George Kitson; Mr Eric Foster (chief public health inspector); Cllr Jack Sutcliffe; Cllr Graham Marshall. Front Row: Cllr Joan Fairhurst; Mr John Hebblethwaite (acting clerk of the council); Revd William Gibson (council chairman's chaplin); Mrs Ada Benbow (chairman's Lady); Cllr Austin Benbow JP (council chairman); Cllr Elsie Gaskell JP (vice chairman); Cllr Alan Pettengell; Cllr Dorothy Pettengell; Cllr Mary Brewer.

Opposite above: Norland Road at its junction with Station Road. The procession collects, ready for moving off. The occasion is the coronation celebrations, 1953.

Opposite below: Sowerby Street, 1953, one of the decorated wagons in the procession to celebrate Queen Elizabeth II's coronation. The tableau depicts the London Olympics of 1948 and the wagon is from the firm of W. & R.K. Lee Ltd, cotton and spun rayon doublers, whose premises were located on Holmes Road. The company, like so many other textile businesses, exists no more and its old factory is today divided up into industrial units.

Above: The celebrations of the coronation of Queen Elizabeth II at Crow Wood Park, 1953. An accordionist entertains a rather damp crowd. There was also open-air dancing and an amateur boxing tournament among other attractions.

Left: Sowerby Bridge bonfire to celebrate King George V's Silver Jubilee, 1935. The bonfire was on Crow Hill and was just one of many events to celebrate the jubilee.

fourteen

Sport
and Leisure

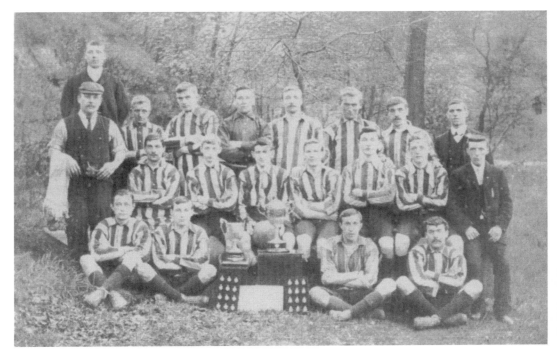

Sowerby Bridge football club, Balmoral, *c.* 1906.

Sowerby Free Wanderers football team at Brockwell, Sowerby, in 1914. The team played on land that is now the Beechwood housing estate. F. Rawson is the officer in uniform.

Sowerby Bridge Prize Band, 1934. They were winners of the Holmfirth Challenge Trophy, Scarborough Trophy and medals, *Courier & Guardian* Rose Bowl and the Wholesale Market Trophy, Leicester.

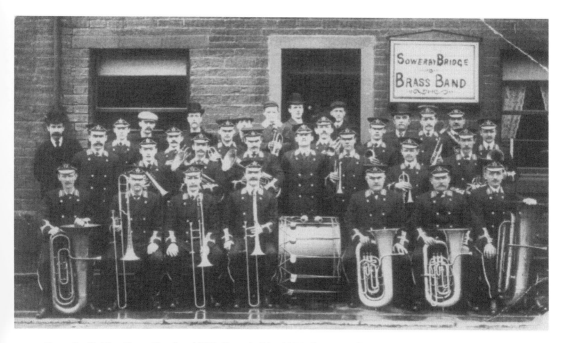

Sowerby Bridge Brass Band, *c.* 1908. Founded in 1881, they met for practice at the Oddfellows Arms and the Brown Cow Inn in Bolton Brow. In 1885, after many fund-raising events, a new band room was opened in Wakefield Road. The band won first prize at the national contest in Crystal Palace in 1911.

The cast of *As You Like It*, Sowerby Bridge Secondary School in (possibly) 1912.

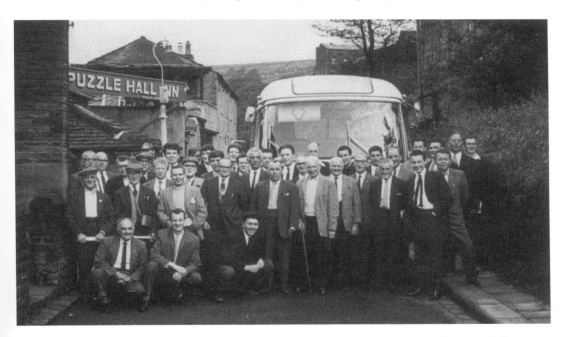

Above: The annual coach trip from the Puzzle Hall Inn, Hollins Mill Lane, 1960s. They invariably went to the races.

Opposite: NALGO members play Sowerby Bridge councillors at bowls. Desmond Howe (surveyors' department.) versus Cllr Harry Haigh (right).

LAST FEW DAYS.
POSITIVELY CLOSING MONDAY, MARCH 12.
TOWN HALL, SOWERBY BRIDGE.
Every Evening at 8.
PROF. WOOD'S
LECTURES AND DIORAMAS
Popular Prices of Admission.
To-Night (Friday) "Love and Matrimony,"
Saturday Night—Last Lecture on 'Palmistry."
Sunday—Two GOSPEL LANTERN SERVICES will
be given, Afternoon at 3-15, "Life of Christ,"
Part II ; Evening at 8-15, "Teaching of Christ,"
including the Grand Effect, the "Rock of Ages."
See Special Programmes.
NOTICE.—In the Evening, owing to the Church Ser-
vice, the doors will not be open until 7-45.
Monday The Last Night—Lecture to Ladies Only.
CONSULTING ROOMS open Daily, from 10 a.m.
to 7-30 p.m. See Handbills.
THOS. R. WOOD, Manager.

An advertisement from *The Sowerby Bridge Chronicle*, 1894. The church services were being held at the town hall due to Christ Church being badly damaged by the recent fire there.

Tom Foy dressed for his part in *Dick Whittington*. Although not born in Sowerby Bridge, he lived in the area for many years and made a living as a comedian. He made over twenty comic records and in one he refers to 'coming down the steps from Sarby Brig station crossing the footbridge, going through the ginnel (passageway) and up to Chapel Loin [Lane]'. One of his songs was 'My farewell to Sarby Brig'. Believed to have been born in Manchester, he died at the age of fifty-six in 1917.

Uniforms

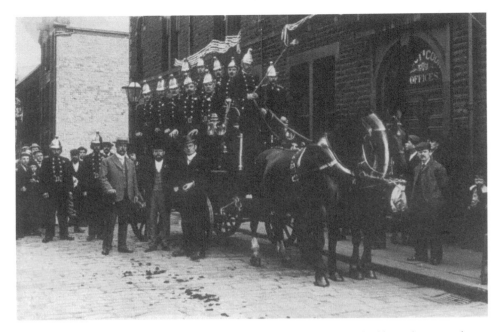

The fire brigade outside the council offices, Hollins Mill Lane, *c.* 1904. The library has yet to be built in the gap between the buildings. The fire brigade was formed in 1866 and in 1904 consisted of a superintendent and twelve men.

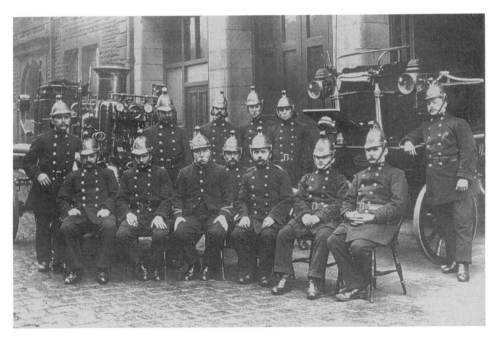

Sowerby Bridge fire brigade. This photograph was taken around 1904 outside the fire station, Hollins Mill Lane. The fire station was closed in 1991 and Sowerby Bridge has been served from King Cross fire station since that time.

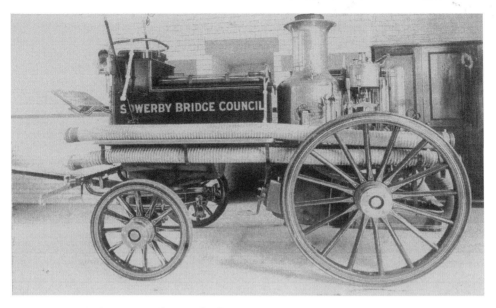

The 'Gem' in the fire station. This was the first steam-powered fire engine in the district. Made by the firm Merryweather Ltd, it could be drawn by two or four horses. The horses were also used to pull the other council carts and it is said that if they were away from the fire station when the siren sounded they were set free and galloped back on their own. The 'Gem' was acquired in 1904 and served the community until 1928 when it was sold. It was replaced by a motor-propelled engine called 'Ellen'.

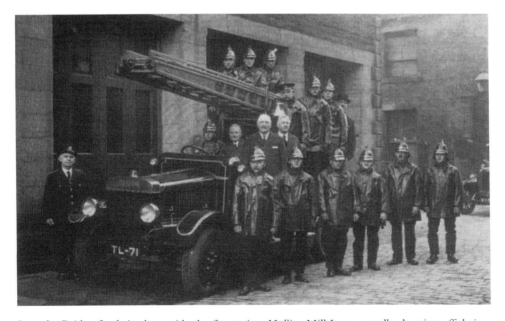

Sowerby Bridge fire brigade outside the fire station, Hollins Mill Lane, proudly showing off their motorised ladder appliance, 1930s. When the fire station closed in 1991 it was the second oldest fire station in the country.

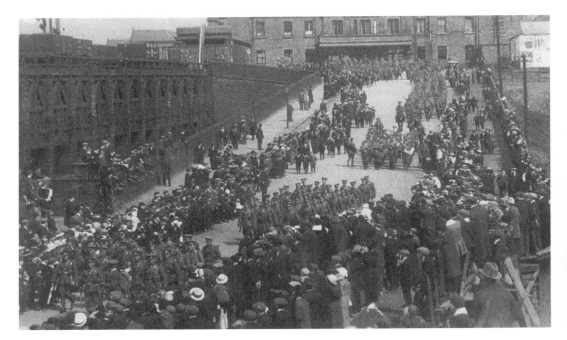

Troops marching down Station Road from the railway station in 1915 during the First World War, led by a band and officers on horseback. Their arrival was obviously anticipated judging by the large crowd in attendance.

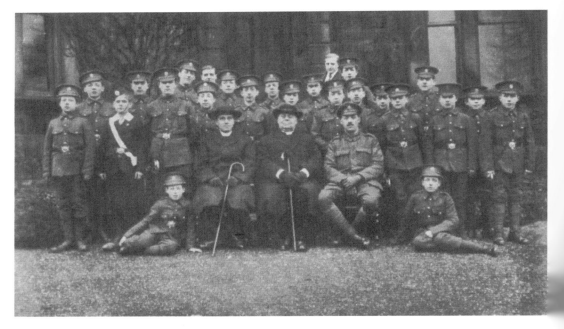

The Revd Canon Ivens, Vicar of Sowerby Bridge, with The Sowerby Bridge Company (No.176) of the C.L.B., February 1917.

The band of the Sowerby Bridge Home Guard, 1940. 'Dad's Army' consisted of those too young or too old to join the regular forces or those in reserved occupations.

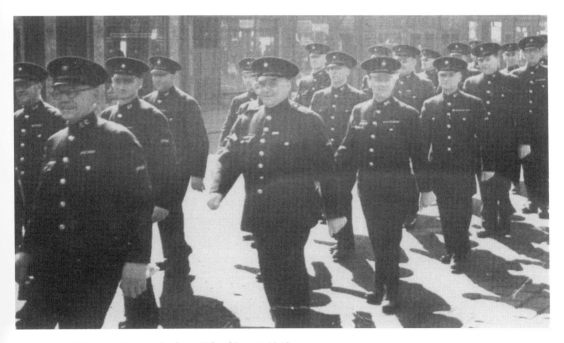

Special Constables parade along Wharf Street, 1942.

If you are interested in purchasing other books published by
The History Press, or in case you have difficulty finding any of
our books in your local bookshop, you can also place orders
directly through our website
www.thehistorypress.co.uk